Combat Art of the Vietnam War

Combat Art
of the Vietnam War

Edited by
Joseph F. Anzenberger, Jr.

McFarland & Company, Inc., Publishers
Jefferson, North Carolina, and London

Library of Congress Cataloguing-in-Publication Data

Combat art of the Vietnam War.

Includes index.
1. Art, American.
2. Art, Modern — 20th century — United States.
3. Vietnamese Conflict, 1961-1975, in art.
I. Anzenberger, Joseph F., 1955–
N6512.C58127 1986 704.9′499597043 85-43570

ISBN 0-89950-197-4 (acid-free natural paper)

Printed in the United States of America.

McFarland & Company, Inc., Publishers
Box 611, Jefferson, North Carolina 28640

For Debbie

Acknowledgments

I want to express thanks and appreciation to all the combat artists and families of such who cooperated in the research of this book. I am especially indebted to those artists who provided firsthand accounts of their experiences in Vietnam. I am grateful to the curators and assistants of the four United States military art museums for their time and resources: Jack Dyer, Marine Corps; Marylou Gjernes and Ed Baines, army; Charles Lawrence and John Barnett, navy; Alice Price and Bob Arnold, air force; and Jim Ward and Ginny Donnelly, Coast Guard. Thanks also to Dennis Roach of the Firebird Gallery, and to Richard Moore, for their background material.

I want to thank Sondra Vocke and the artists of the Vietnam Veterans Arts Group with whom I associated, as well as the dozens of people who had written me in response to my initial search request.

It was not possible to contact every artist of the war, nor to depict every piece of related art. Choosing the art for this book from among thousands of works, representing a tremendous amount of talent and hard work, was a difficult task. Artwork not included should not be considered inferior in any way to what is presented here.

Table of Contents

Introduction

"The Secretary of the Army invites you to proceed on or about 9 July 1967 from Boston, Massachusetts to South Vietnam, for a period of approximately thirty (30) days to engage in the Army's Combat Artists Program.... The travel to be performed is necessary in the public service."

For Theodore J. Abraham, a volunteer civilian artist representing the Copely Society of Boston, these "International Travel Orders" meant thirty days of sketching his way through scenes such as helicopters evacuating the wounded from the Central Highlands of South Vietnam or a soldier taking a short break between monsoon rains to read a letter from home. Abraham's resultant sketches were hardly the type of artwork commonly found in someone's portfolio.

Yet today his sketches are museum pieces, part of the army's $7 million appraised-value inventory of Vietnam combat art. Similar combat art collections of the Marine Corps, air force, navy, and Coast Guard, along with private collections owned by military associations or the artists themselves, comprise thousands of graphic representations of the United States at war.

Photography for the most part played the leading role in visually documenting the Vietnam War. High-speed video communications pushed the seemingly more cumbersome methods of illustrating the news further into obscurity. To say the least, arts such as drawing and painting were not considered an effective means of visual journalism. The general feeling regarding military-sponsored combat art was that it was nothing more than glazed propaganda, a leftover of World War II sentimentality — a feeling which left such art virtually ignored. Likewise, as a result of the unpopularity of the war itself, characterized by general American opinion, many nonaffiliated artists — those who simply drew from their experiences as soldiers or marines and who drew for the pure sake of drawing — were never really given serious attention when attempting to show their work.

Combat art's intended exposure to the public has never been fully realized. This lack of exposure has unfairly left the artwork without close scrutinization and the artists without recognition of their efforts. As a result, the bulk of these artists' contribution to this special form of art retired itself to the walls of government offices, the storage rooms of military museums, and the basements, closets and garages of America.

Part of the problem is a misunderstanding of the correlation of art and war. The artist struggles with creativity; the soldier struggles with destruction. Art can suggest passion and reflection; war suggests suffering and stress. An artist looks at an object or scene and describes it through an energetic stroke, through a flow of hands and tools, depicting a version of reality with a perception that may tax the imagination. A soldier attempts to survive in chaos and disorder, in a contest of life and death that taxes the emotions.

What is misunderstood is the unlikely marriage of art and war — when the artist puts himself in the soldier's boots, or the soldier is an artist himself. When this marriage takes place, two artistic styles consistently emerge — exposive, bold and straightforward representations of life in war, or concussive interpretations of horrid experiences that may be difficult to view, yet scream for understanding. In either case, realism and understanding are the objectives.

To study the combat artist and his way of depicting the Vietnam War, the museums, closets and basements must be explored, the artworks found, the artists located. A cross-section of the overall work must then be selected. Finally, the artists must reflect on and explain their reasons or objectives for choosing particular subjects.

This book is intended to present representative works of combat art and a few of the artists' stories. Combined, the works and the stories depict the fear and anger, honor and glory, courage and peril, boredom and routine, and life and death of the people of the Vietnam War.

Background

The illustrating of American military involvements dates back to the Revolutionary War. John Trumbull's numerous sketches and paintings of the era preserved the significance of such events as Lord Cornwallis's surrender at Yorktown and the incarceration of Continental Army soldiers aboard the British prison ship *Jersey*. Other, lesser-known artists such as Amos Doolittle, a Connecticut militiaman who engraved the battles of Lexington and Concord, and Thomas Davies, a British officer who produced a series of watercolors on the attacks of Fort Washington and Fort Lee, were among those who actually witnessed the battles they drew. Portraitists such as Gilbert Stuart and Joseph Wright added to the vigor and hope of the newborn republic with their paintings of major figures of the period.

Later, into the early nineteenth century, Thomas Birch became known for his commissioned paintings of important naval battles of the War of 1812, but it is unlikely he witnessed any of the encounters firsthand. In fact, between the American Revolution and the Civil War, few artists based their military-subject work on personal observation. An exception was James Walker, who served as an interpreter in the Mexican War of 1846–1848. During his service, Walker produced twelve oil sketches of the war; his mural of the Battle of Chapultepec, which now hangs in the gallery of the Marine Corps Museum in Washington, D.C., came later.

The Civil War brought out a highly competitive and motivated group of artists employed by such periodicals as *Century, New York Illustrated News*, and *Harper's Weekly*. The primary objectives of these artists were to search out the battles and fortifications of the war and provide a visual accounting of the situation for the publications' general readership. Their job, to say the least, was demanding both physically and logistically. Travel through the regions was dangerous and harsh; couriers had to be relied upon to return the sketches to the artist's parent publication; and the wood engravers back in the print rooms had the task of reworking the unfinished sketches in accordance with instructions accompanying the illustrations. Despite the difficulties of the job, however, Thomas R. Davies of *Harper's Weekly* is credited with drawing over 250 sketches during the war and for covering more battles than any other artist of the time.

Few of the original sketches made by the artists of the Civil War still exist. Many were simply thrown away once they were printed. Fortunately, in 1888, *Century* magazine published the four-volume *Battles and Leaders of the Civil War*. Although the illustrations are reproductions of the printed originals or were reconstructed from photographs and memories, the plates to the book are considered the primary source of surviving combat art of the period.

Charles Johnson Post, during the Spanish–American War in 1898, filled two sketchpads with drawings of his experiences with the Seventy-first New York Volunteers in Cuba. He later developed his sketches, which are now the property of the United States Army Center of Military History, into various paintings and a single book, *The Little War of Private Post*.

Around the same time, the opening of the West pitted the United States Cavalry against the plains Indians, which served to fuel the imagination and talent of Frederick

Remington. Remington had served as a war correspondent during the Spanish–American War. As a reporter and artist of military and Indian life for *Harper's Weekly* and *Outing* magazine, Remington produced more than 2,700 works of art during and about that period of American history. One of his more famous paintings, *Indian Warfare*, concerns the recovery of a dead or wounded comrade during the heat of battle.

In World War I, Colonel John W. Thomason, Jr., USMC, produced hundreds of sketches and paintings depicting marine military actions. All of his work is now stored at the Sam Houston State University Collection in Houston, Texas. The only other substantial collection of that war is what is known as the official art history of the American Expeditionary Forces. This collection, produced by a team of eight artists spearheaded by J. Andre Smith, is now permanently housed at the Museum of American History in Washington, D.C.

The official government title of "combat artist" came into being shortly before World War II when Lt. Commander Griffith Baily Coale organized navy artists into the Combat Artist Corps (CAC). Coale produced the first piece of art through the CAC program—a painting of an escorted naval convoy churning through the northern Atlantic prior to America's direct involvement in the war. The CAC continued to produce a large number of artworks during and after the war until its breakup in 1960. Among the more notable contributors during CAC's existence were Mitchell Jamieson and Walt Disney. A number of other World War II paintings produced by civilians, such as Kerr Eby, who was sponsored by Abbott Laboratories, were donated into the navy's art collection after the war.

Meanwhile, the United States Army Corps of Engineers in 1942 established the War Art Unit under the auspices of artists Reeves Leuwenthal and George Biddle in conjunction with the Associated American Artists. Forty-two selected civilian artists were tasked by an army directive to depict events of outstanding military importance, incidents in the daily life of the soldier, frontline operations, combat, service support and characteristic views of the countryside in which operations were conducted. But within a year, the War Art Unit was terminated without official explanation. The cancellation of the unit prompted Daniel Longwell, the executive editor of *Life* magazine, to offer to the army a similar art program: The magazine would pay the artists' salaries and later donate all completed works to the army, provided the army transported and housed the artists throughout the war. The army accepted the offer and, as a result, was supplied with more than 2,000 works of art of and about their role in the war. A similar offer by Abbott Laboratories netted a number of medical scene paintings. Following the war, *Yank* newspaper donated their entire collection of general art and cartoons printing during the war years.

The Marine Corps, during World War II, assigned Raymond Henri to establish their own art program. However, the program lacked the proper funding for storage, and Henri was forced during the postwar demobilization to disburse all the received art, which had been produced by marines in the field during the war. It would be another twenty years before an appeal was sent back to those marines to redonate their work to the Marine Corps Historical Branch for permanent housing. Among the more notable marine artists of the period were Hugh Laidmand and John McDermott.

Very little attention was given to organizing any military art program during the Korean War, and very few paintings from or about it are known to exist. Possibly the most active artist during the period was Avery Chenoweth of the Marine Corps, whose painting *The Road Back* is often reproduced alongside articles on the war.

During the Korean War era, however, the air force art collection was beginning to lay a foundation. Approximately 800 combat

paintings, primarily of World War II, were transferred from the army to the newly formed air force. In time, the collection would build into an inventory of more than 6,000 pieces of art.

By the escalation period of the Vietnam War, all five United States military services had an organized historical branch, and each began actively to establish an ongoing combat art program. In 1966, the Department of the Army began sending artists to Vietnam under a program that included both reassigned active-duty soldiers and professional artists from the Salmagundi Club in New York. The navy, air force and Coast Guard all utilized civilian artists only, while the Marine Corps relied mainly on their own rank and file.

For the army, soldier artists were selected by the Center of Military History from applications submitted by qualified personnel who were recommended and eligible for release from their regular duties to this special assignment. The required qualifications included an ability to record military events and experiences pictorially and with strong emotional impact. The artists were encouraged to depict their subjects in their own way. Each soldier was sent to South Vietnam for fieldwork and then sent to a studio in Hawaii to finish. The completed art was then turned over to the center and the soldiers returned to their previous duties. The entire tour normally lasted 120 days.

For the civilian artist, the army paid all regular expenses accrued by the artist, including travel to and from South Vietnam. In return, the civilian artist handed over all completed works within a year.

All told, thirty-six soldiers and ten civilians participated in the army program during the Vietnam War, producing about 2,000 pieces of art. Today, an army art program still exists. However, due to monetary and staffing limitations, the civilian program has been dropped. Display of the work produced during the war is arranged through the army's Traveling Exhibit Program.

The Marine Corps accumulated more than 3,000 works during the Vietnam War through their combat art program. Raymond Henri, once again in charge of the program as he was during World War II, decided not to rely on the professional civilian agencies, but rather to recruit artists out of the marines' own ranks. While some civilian artists did do artwork for the marines (such as John Groth, who is recognized as the "dean of combat artists"), the majority of artists were men with titles such as lance corporal, chief warrant officer and colonel, who were cut special orders to sketch fellow marines in Vietnam. Assisting Henri in establishing and maintaining the Vietnam program was Albert "Mike" Leahy, who himself toured South Vietnam twice as a combat artist. The Vietnam collection is now housed inside the Marine Corps Historical Center in Washington, D.C.

When the navy's uniformed Combat Artist Corps disbanded in 1960, the Navy Art Cooperation and Liaison Committee Program (NACAL) was established at the Salmagundi Club in New York and the Municipal Art Department of the City of Los Angeles. Supervised by the navy's chief of information, NACAL artists produced more than 300 paintings and drawings during the war. Arrangements with the artists were similar to what the army offered in the way of free transportation and billeting during their tour. Predominant artists in the collection include John Charles Roach, John Steel and Charles Waterhouse. The navy's combat art collection of the Vietnam War is stored at the Navy Yard in Washington, D.C.

The air force Vietnam collection was produced almost entirely by civilians, also under special arrangements like the army's and navy's. The air force collection is smaller in volume than those of the army, Marine Corps and navy, yet of the approximately 200 paintings of the war, almost all are on public display at either the Pentagon or the Air Force Academy in Colorado. While many of the air force scenes of the war are of air-

craft operations, their art depicting the prisoner-of-war drama, felt heavily by many air force personnel and their families, creates a touching chapter unseen in the other military collections of the period. One artist, Maxine McCaffrey, dedicated much of her time in South Vietnam to researching POW-related situations and produced a number of paintings on the subject, including a series of sketches chronicling the POW release in 1973. Theodore Gostas, incarcerated by the North Vietnamese for five years, highlights the POW collection with his artistic descriptions of four and a half years of solitary confinement.

The Coast Guard is best known for its humanitarian rescue missions, yet has fought in every war in which the United States has been engaged. Like the other services, the Coast Guard maintains an art collection but, in comparison, not as intensively. In 1969, civilian artists Noel Daggett and Apollo Dorian were invited to tour Coast Guard facilities in South Vietnam and record their impressions on canvas. As a result, thirty-three paintings of Coast Guard activities such as coastal patrols and orphanage visitations comprise their Vietnam collection, now housed in Maryland.

Finally, a scattering of lesser-known combat-related art is sometimes exhibited in small galleries across the United States, but more likely than not is stored in closets, under beds and in attics. Unassociated with any government program, many of these pieces of art were never originally intended to be publicly scrutinized. Art of this nature was produced by combat veterans who used their artistic skill to express their feelings about the war in a way they believed no spoken word could justify. It has taken time for these works to surface; many of the artists feared rejection or misunderstanding of their work. However, the Vietnam Veterans Art Group, a Chicago-based, self-funded organization of "maverick" combat artists, has persuaded many to exhibit their work through the group's traveling art show. The shows have received favorable reviews from critics in New York, Washington, D.C., and Chicago, and it has been noted that their contribution to the recording of the Vietnam War is just as important and effective as any government-held collection.

Action

During the afternoon of August 2, 1964, the U.S.S. *Maddox* reported that, while passing off the coast of Hon Me Island in the Tonkin Gulf, it had been fired upon by three North Vietnamese torpedo boats. By 11 A.M. the next day, sixty-four American naval aircraft attacked the oil port of Vinh and three other North Vietnamese bases along the coast in retaliation. Operation PIERCE ARROW, as the mission was named, marked the United States' direct contact entrance into the undeclared Vietnam War. NACAL artist Edmond J. Fitzgerald, although not an eyewitness to the so-called Tonkin Gulf incident, captured the scene in a painting that shows the Maddox returning fire and hitting an attacking North Vietnamese PT boat—a scene that would lead America into a generation of confusion and misunderstanding.

Following the Tonkin Gulf incident, the next major offensive by the United States was the landing of marines on the beaches of Da Nang on March 8, 1965. One might find it fortunate that this incident was not recorded on canvas, since the only action the marines saw that day was the handing out of welcoming leis by South Vietnamese schoolgirls. Yet, despite the comicality of the "assault," the reality of war struck quickly, and thirty-four marines were killed and 157 wounded by that June.

Eighty-two thousand more United States troops would arrive in South Vietnam within the first six weeks of the marine landing, 184,000 more within the first year and more than two and a half million in total for the war's duration.

By the time the war ended for the United States on April 30, 1975, 56,939 soldiers and airmen had died, 2,434 were considered missing, and 566 American prisoners of war had been released.

A few more than 200 government-sponsored artists recorded the war in sketchbooks and on canvas. George Dergalis, an artist under the army's program, summed up what motivated him, and possibly other artists like him, to become involved in what has come to be known as America's most unpopular war: "I chose to volunteer in the combat artists program out of curiosity. I wanted to understand just what was happening over there based on all the controversy caused by the antiwar protesters. Moreover, I wanted to find out if our own government was telling the truth. I had already served in two wars as a combat soldier and I was curious to see what it was like to be an onlooker, a combat artist."

Combat artists were generally free to travel to whatever place or situation they wanted to so long as it was tactically possible. Many chose to become directly involved in hostile situations to ensure accuracy and feeling within their work. But as John Groth, a veteran artist of seven wars and respectfully known as the "dean of combat artists," once noted, "In every war you see the same guys fighting—the eighteen- and nineteen-year-olds—all with the same look."

Avery Chenoweth, a marine combat artist since the Korean War, was one of those who regularly chose to be as near to the war as possible. Now he reflects on those experiences:

In both the Korean and Vietnam wars, the blood and gore and the destruction and horror never appealed to me as subject matter. I instinctively sought out the moments of

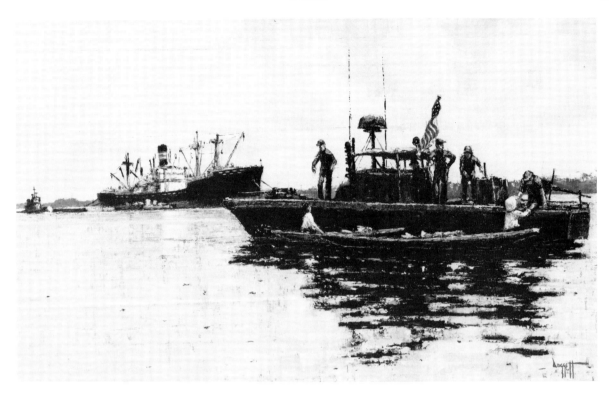

Noel Daggett. *Sorry, But We Have to Inspect You*. Oil, 1967. United States Coast Guard Art Collection.

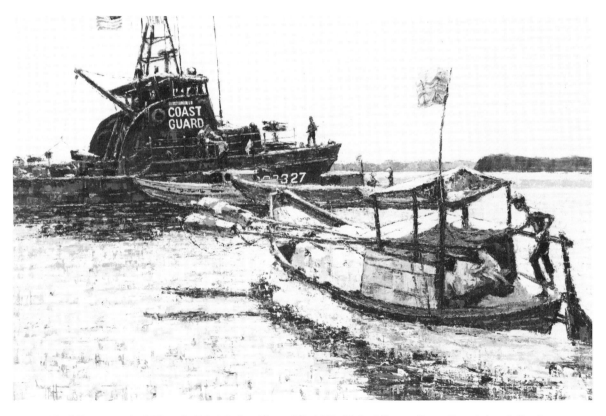

Noel Daggett. *And They Call It Market Time*. Oil, 1967. United States Coast Guard Art Collection.

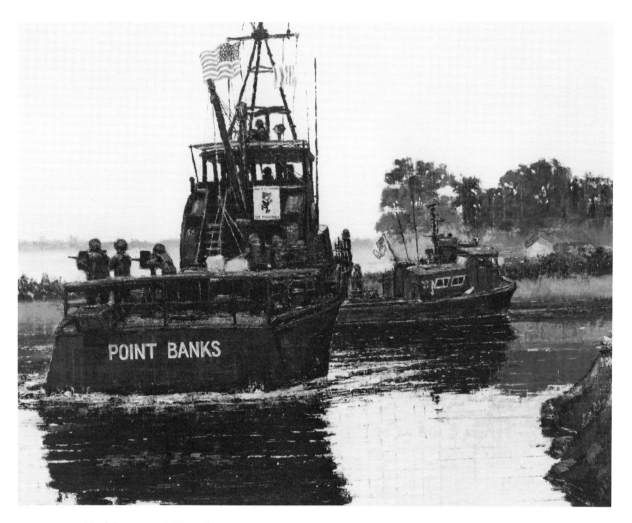

Noel Daggett. *A War of Persuasion*. Oil, 1967. United States Coast Guard Art Collection.

contrast to depict, the interludes of beauty amidst the ugliness. Also, I tried to capture the essence of the atmosphere of a combat environment — the material, the machines, the hard contrasts against the softness of nature, and man's impositions of weapons of destruction into the serenity of nature.

As a portrait painter primarily, I was more interested in people — their faces and their attitudes. I was interested in how they looked, recording them with an artist's selective eye rather than the all-encompassing lens of the camera. In both wars I covered, the inactivity exceeded the activity and these were the glimpses most easily captured — the waiting before battle, the breathers afterwards.

Personally, my experiences had very little upsetting psychological effect either on me or my artistic expression. While having been both a participant and an observer, I never felt an overpowering desire to express a deep social commentary about war or life and death. Perhaps this was somewhat due to a sense of history or my "generation." Or it may be from having been a career military man that I do not look upon the actions of my country with as critical an eye as those who were not career-oriented.

Sketching combat scenes firsthand obviously carried the element of flirting with danger and death. While many combat photographers were fatally wounded in their

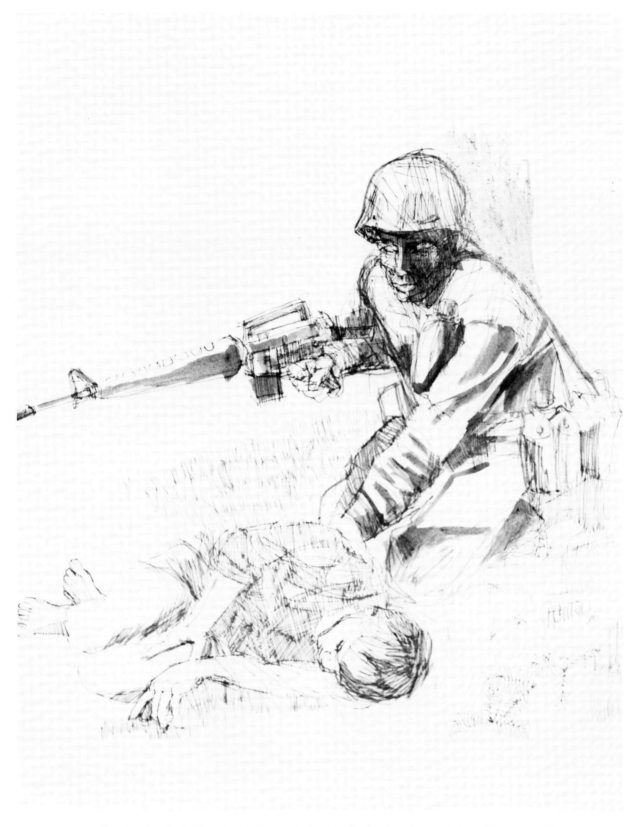

Augustine Acuña. *Body Count*. Ink, 14″×11″, 1966. United States Army Center of Military History.

job, no member of the Vietnam military combat artist programs died pursuing his work—a fortunate statistic, considering that many of the artists did not carry a weapon. The artists relied on the guardian eyes and reactions of their subject GIs.

Charles Waterhouse, a veteran of Iwo Jima and now the Marine Corps artist-in-residence, was a NACAL artist during Vietnam. He describes in one of his books, *Vietnam Sketchbook*, that his gear as a combat artist in the field consisted of a map case containing several sketchbooks, a paint set, an Instamatic camera, pockets full of film and enough plastic bags to keep his work dry. The only thing close to a weapon on him was a knife.

George Dergalis reflects on an incident that brought him in direct contact with a Viet Cong while sketching for the army:

I had joined a detachment of the Eighty-first Airborne Division, which was guarding Saigon River oil supplies, and had overheard that the next day an officer was going on patrol to a small village only a few miles away to deliver fifty dollars in war damages for the accidental death of an old villager—a stray shell had exploded in the old man's house earlier.

So, early after breakfast the next morning, I joined the column of jeeps and armored vehicles that was heading towards the particular village. We crisscrossed through jungle terrain, dirt roads and isolated villages. I soon realized that Vietnam was one of the most uniquely beautiful countries that I have ever seen as an artist.

However, during the journey, the officer and two riflemen assigned to protect me explained that the other side of the river we were near was Viet Cong territory; one could see the Viet Cong flag flying. I was told that there was an unspoken code that if we didn't bother them, they would not bother us.

When we arrived at the village, we were told that there would be a tea ceremony before the money was to be paid. I asked permission to go down to the river to sketch but was warned by the officer in charge that just fifty yards beyond the spot I hoped to occupy was enemy territory. I could go to the river and sit, he told me, but must not venture any further.

The GIs assigned to protect me refused to go along, saying they could not properly protect me in that location. In turn, they gave me a .45 and a couple of grenades. I was told to scramble—take a few pictures and get out fast. I promised to do as they said but found that the spot was too tranquil and the water too refreshing for me to hurry.

I sat on a rock and observed some Vietnamese working among the reeds on the other side of the river. I lit my pipe and began drawing. All my thoughts were then concentrated on drawing the village on the opposite shore.

Suddenly, I noticed two bare feet on the ground next to me; there had been no sounds. I glanced to my left and saw the black pajamas, the mark of the Viet Cong. My heart changed pace and began beating rapidly. I told myself to remain calm, but there was a tremble in my hand. You must continue to draw no matter what, I said to myself. Abruptly, there was a pull on my pipe and the person in the pajamas grabbed it from my mouth violently. I looked up to see a face, not of a smiling peasant, but of a stern, suffering one of a man who apparently had seen much combat. I tried to smile. Then again, violently, a cigarette was stuffed into my mouth by some clubbed extremity not at all like a hand. The Viet Cong soldier then began puffing on my pipe with satisfaction while I smoked his cigarette. It occurred to me that all of this person's movements and gestures were like those of some wild beast. As I once again began to sketch, he came

Opposite: Roger Blum. *Patrol in a Rice Paddy, Vietnam*. Watercolor, 10″×14″, 1966. United States Army Center of Military History.

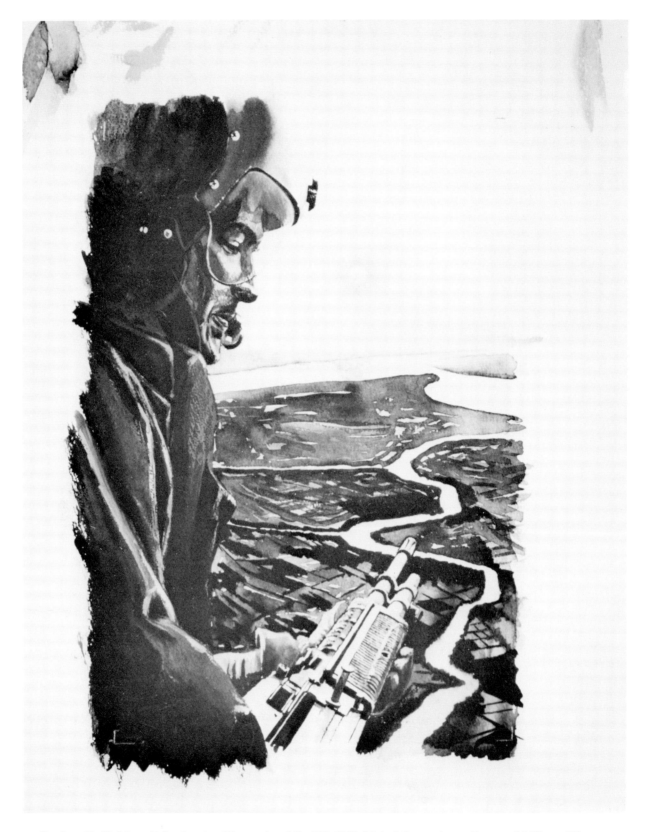

Stephen H. Sheldon. *Delta Sunrise*. Watercolor, 16″ × 13″, 1966. United States Army Center of Military History.

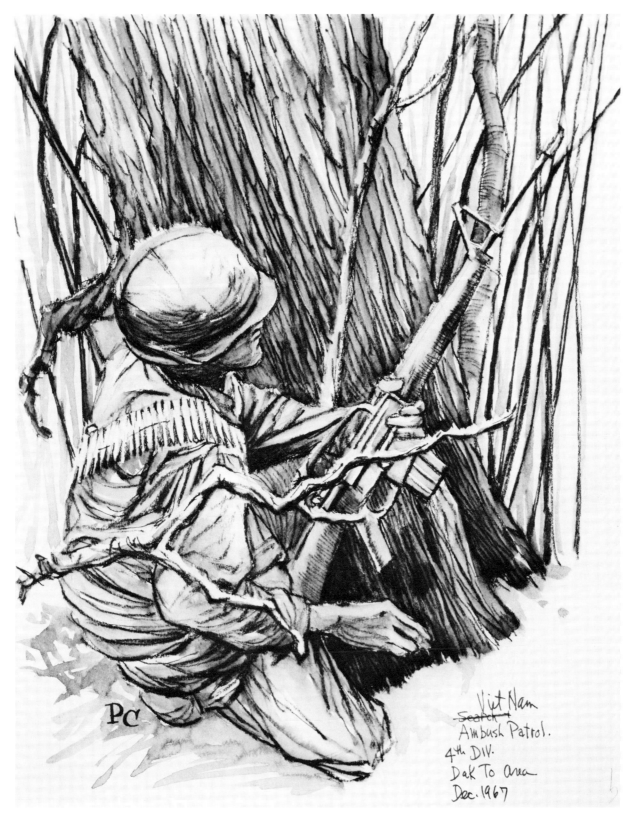

Viet Nam
~~Search~~
Ambush Patrol.
4th DIV.
Dak To area
Dec. 1967

Peter Copeland. *Vietnam Ambush Patrol*. Watercolor, 14″×11″, 1967. United States Army Center of Military History.

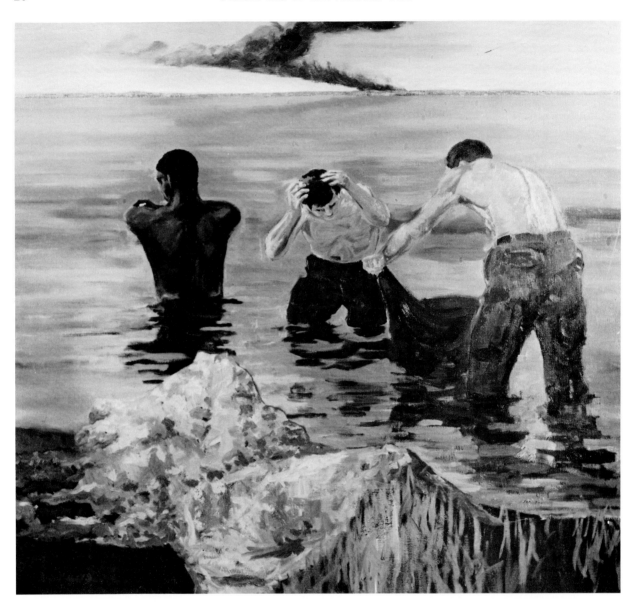

Robert T. Myers. *Wade in the Water*. Oil, 42″ × 46″, 1967. United States Army Center of Military History.

closer to me and bent over my shoulder. It was then I observed the grenades strung around his belt that was holding a revolver as well.

For a few split seconds many things crossed my mind. Were my protectors watching this scene? Did they have their rifles trained on this individual, our enemy? Was I a total fool since I had been warned not to come to this spot to draw? Should I pretend to get some tobacco and then try to shoot him myself? Or would he succeed in shooting me first?

I decided that I had come to this spot to draw and that was exactly what I was going to do. But as I continued on my task, I watched his feet for movement.

Without warning, his paw hit me on my back. I looked up and saw he was smiling in approval of my work. The pictured boats, the bamboo poles and the working peasants seemed to truly fascinate him. He then hit me again and seemed to signal that he wanted his portrait done and seated himself on a rock about two feet away. I in turn, signaled and

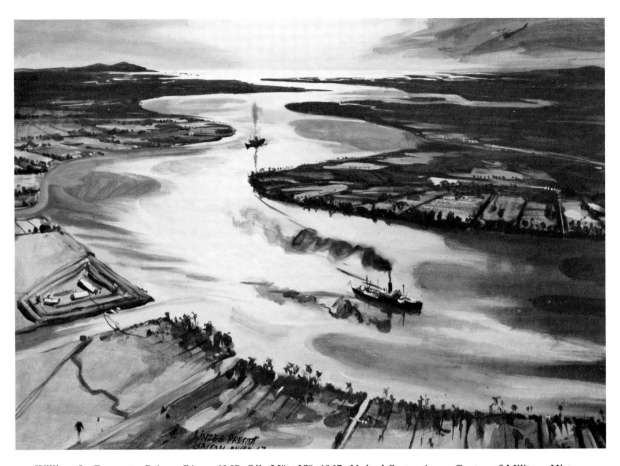

William L. Prescott. *Saigon River, 1967*. Oil, 25″ × 37″, 1967. United States Army Center of Military History.

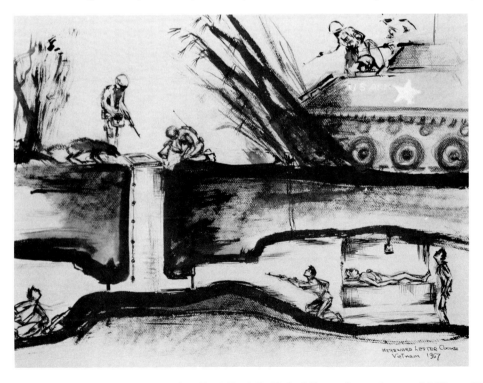

H. Lester Cooke. *Bringing 'Em Out*. Ink, 19″ × 24″, 1969. United States Army Center of Military History.

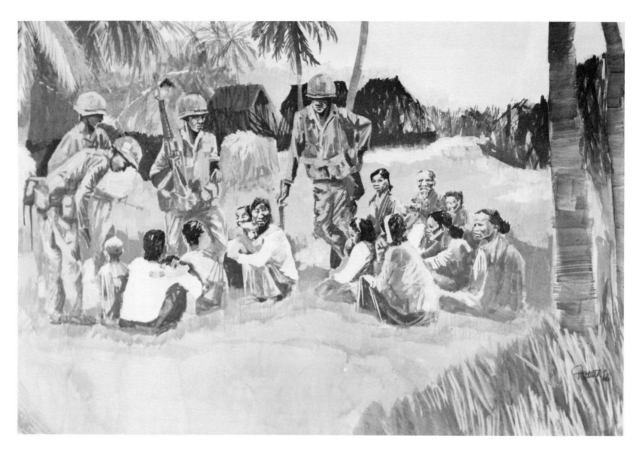

Augustine Acuña. *Roundup and Questioning of Villagers — 1966*. Watercolor, 18″ × 28″, 1966. United States Army Center of Military History.

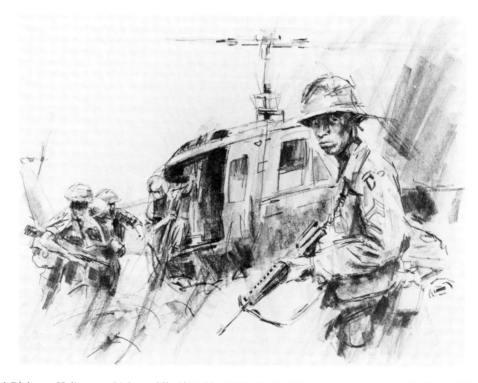

Paul Rickert. *Helicopter Pickup*. Oil, 52″ × 32″, 1966. United States Army Center of Military History.

gestured with my hands to ensure that he did indeed want me to sketch him. He walked over and forcefully turned to a blank page in my sketch pad to clarify what he wanted.

I started to draw my new-found friend rapidly, glancing up frequently at his beaten, scarred face ravaged by war. I sought to understand this man who appeared to be in his twenties. Then, as he sat there posing, a miracle took place before my eyes. The angry countenance of the soldier disappeared and a peaceful look came over him. To my surprise, he even smiled. Quite a few of his teeth were missing but one gold one shone in the sun. Surprisingly, another transformation took place: I was now in total control. At first, he had been the one pushing and ordering me about. Now, I ordered him, telling him to sit straight, to smile and to keep his eyes focused forward. At one point, he had run out of tobacco in the pipe yet remained calm as I reached for my pouch. He knew that I was armed, but we were both involved in the drawing too much. My heartbeat had returned to normal.

How long it all took I don't know. But I saw that when he relaxed, I was truly able to

capture his likeness. He got up when he saw that I was done, and I saw he was pleased.

He beamed as he tore the page from my sketch book and then patted me somewhat roughly on the back. With his hands, he gestured that I should remain sitting where I was and not to move.

Was this it, I thought? Now that his portrait was complete, was he going to shoot me? Again, my heart began to race. Instead, the soldier disappeared into a hut nearby and shortly returned with his hands behind his back, yet he moved like a child, almost shyly. He then pulled from behind his back a framed picture of a Buddha and gave it to me. In satisfaction, he then walked away about ten paces.

After a few moments, I decided I wanted to finish my first drawing of the boats and villagers and continued to sketch, the soldier watching me all the while. When I was satisfied with my rendering, I got up. He waved to me and I waved in return. Leaving, I still felt uneasy about having to turn my back on him. As I approached my awaiting group I saw that they had been watching the whole scene with rifles pointing.

Ronald A. Wilson. *Apprehended.* Acrylic, 20″ × 40″, 1967. United States Army Center of Military History.

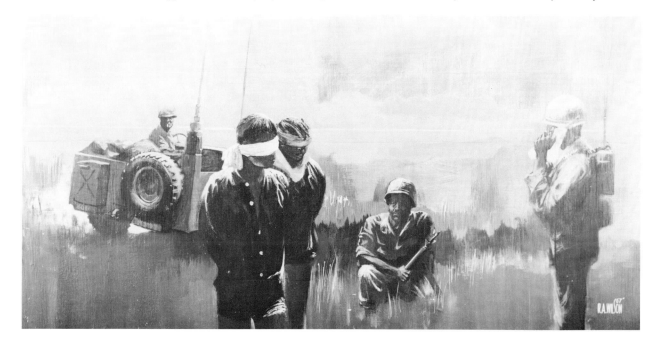

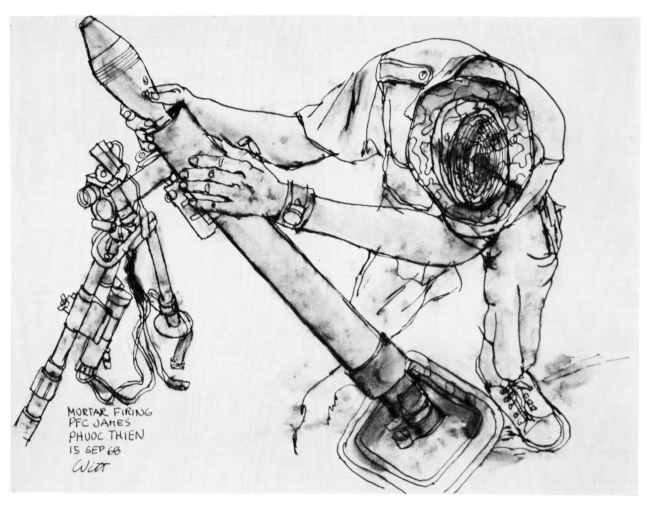

John J. Witt. *Mortar Firing*. Pen and ink, 9″ × 12″, 1968. United States Marine Corps Art Collection.

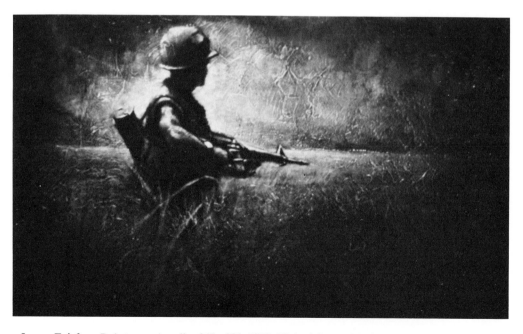

James Fairfax. *Pointman*. Acrylic, 34″ × 23″, 1970. United States Marine Corps Art Collection.

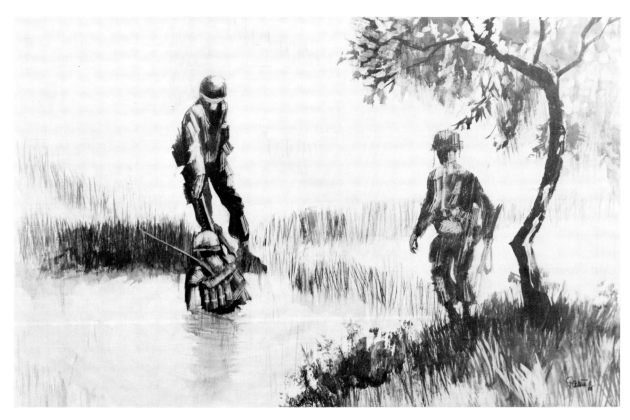

Augustine Acuña. *Rice Paddies — Vietnam, 1966*. Watercolor, 18″ × 28″, 1966. United States Army Center of Military History.

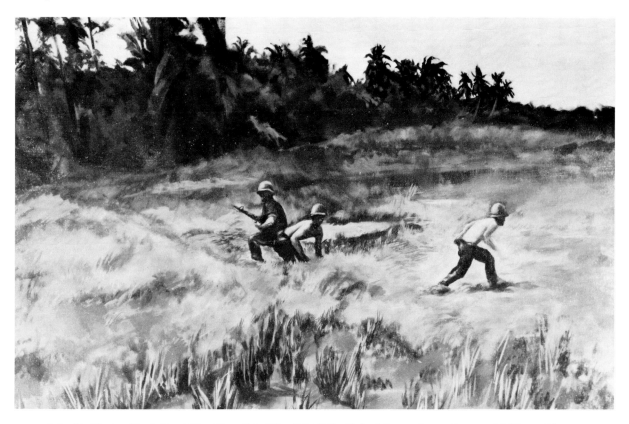

John D. Kurtz. *Firefight at Thu Doc*. Oil, 30″ × 40″, 1968. United States Army Center of Military History.

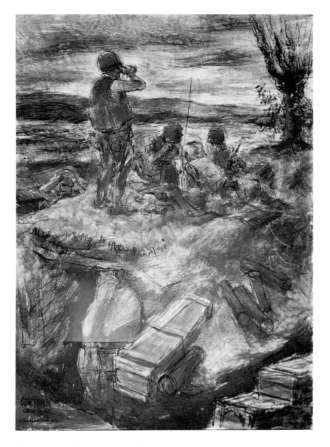

H. Avery Chenoweth. *Con Thien Run.* Acrylic, 1967.
United States Marine Corps Art Collection.

John Groth claimed that one of the
problems in illustrating the combat soldier
was that even during skirmishes, invariably
one soldier would see what he was doing and
ask for a picture. Within minutes, a line of
guys would want their pictures done.

SP5 Stuart M. Richel, in an article that
appeared in the Winter, 1970, issue of *Danger
Forward* (the magazine of the 1st Infantry
Division), describes the subject of these
drawings:

*The man is a youngster, a teenager, but
a seasoned veteran. He is a man. To believe
otherwise is folly; but to gape at such truism
is to be astounded by the obvious.*

*Where there is work to be done, no one
is more capable. If the chore be mundane, he
will do it, though perhaps not [with] blind-
ing speed. Where the task is of importance,*

*no one will delay him. That danger crosses
the path is of no consequence. Some of his
kind have gone beyond hell, and can look
back with disdain. Their heritage, their
training, their pride in country—all these
dictate that the man respond with courage
and dignity.*

*Let his manliness not belie his gentle
nature. His conscience mourns the creation
of death, and the labors and tactics which
bring out such lifelessness. Though oncom-
ing hordes will not incapacitate him, his
heart will cry out for a child in distress.*

*His body is covered, not with modern
fashion, but with the rags and grime of
war. He looks to his sleeve or a towel
around his neck to remove the stain, not
fortunate enough to have greater conven-
ience at hand.*

*The clouds around him are hardly
silverlined. They are laden with rain. They
are simply makers of mud. Their only
redeeming value is as a buffer, stopping the
sun from beating down mercilessly.*

*As if to tease, the sun will replace the
unbearable rain, move on to produce
equally unbearable heat, and dry the feet sore
and rotted. The man takes it, doing what he
must, doing whatever he can.*

*He warms his food, if at all, with the
heat from stick-like explosives, rather than a
gas range. His food is usually tolerable, but
becomes quite tiresome after nine or ten
months of similarity. Fruit cocktail and
pound cake are delicacies, much the same as
snails and caviar to the Beautiful People. The
fruit and cake are to be sought with
diligence, protected with all but life itself.*

*Don't speak of loneliness to him. He
knows it too well.*

*Don't preach of losses and the meaning
of death. He has a history which enables him
to count higher than you. And no one has
undergone more of the experiences which
make a gut cherish life and what it has to
offer. He has lived and fought with great
friends, some of whom will return home. But
he notes the irony that those who live, live*

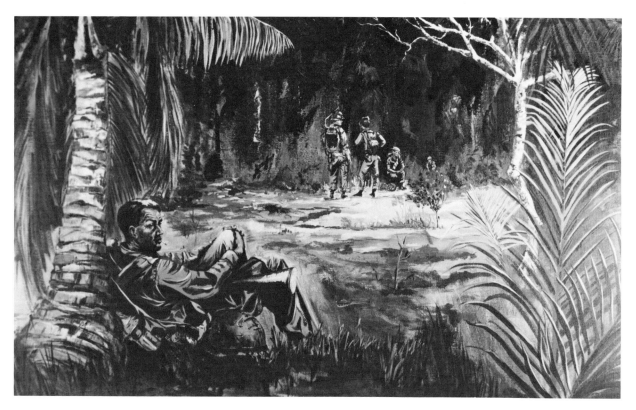

Kenneth J. Scowcroft. *A Tired Warrior*. Acrylic, 24″×36″, 1967. United States Army Center of Military History.

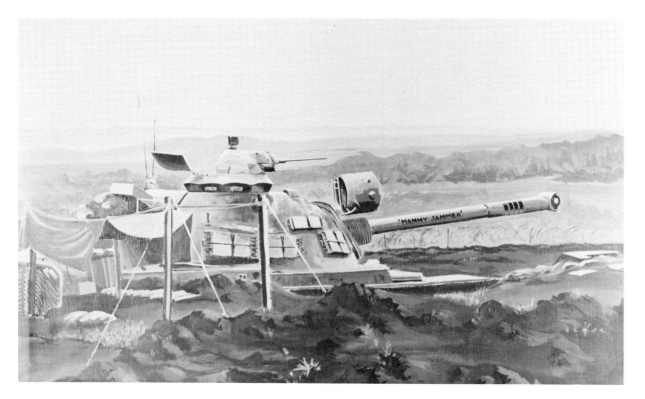

Michael R. Crook. *Vigil on the DMZ*. Acrylic, 28″×40″, 1967. United States Army Center of Military History.

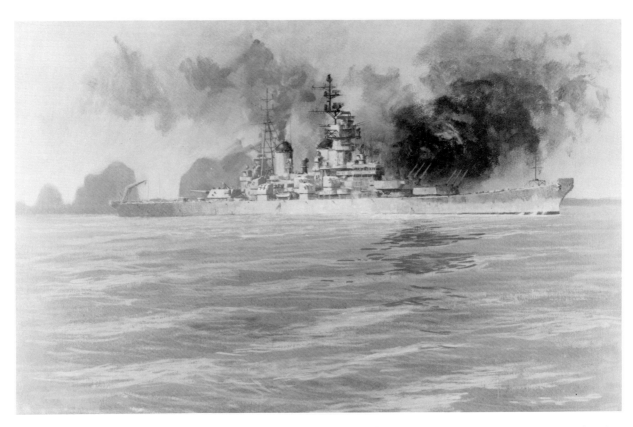

John C. Roach. *USS* New Jersey *off Da Nang, Firing Inland*. Tempera, 30″ × 38″, 1969. United States Navy Combat Art Collection.

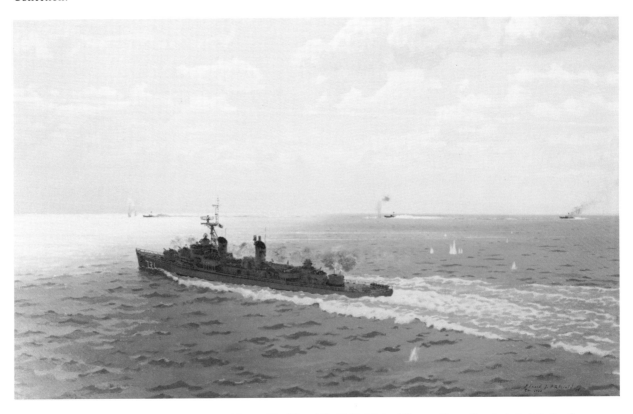

Edmund J. Fitzgerald. *Tonkin Bay Incident*. Oil, 51″ × 65″, 1965. United States Navy Combat Art Collection.

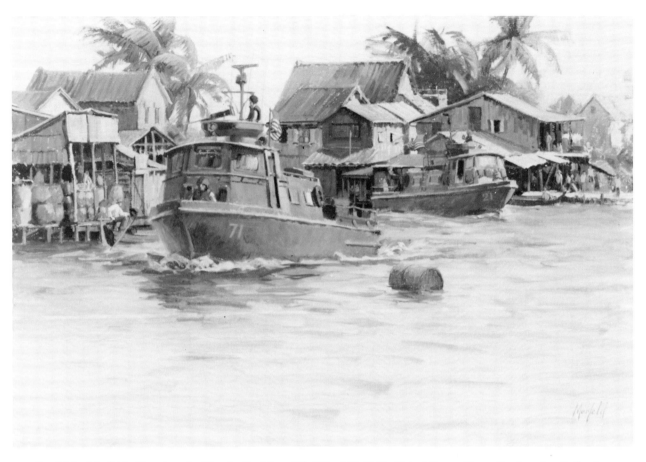

Gerald L. Merfeld. *Showing the Flag in Ca Mau*. Oil, 28″ × 34″, 1969. United States Navy Combat Art Collection.

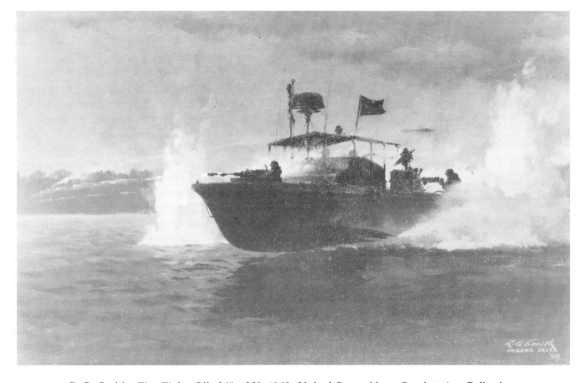

R.G. Smith. *Fire Fight*. Oil, 24″ × 30″, 1968. United States Navy Combat Art Collection.

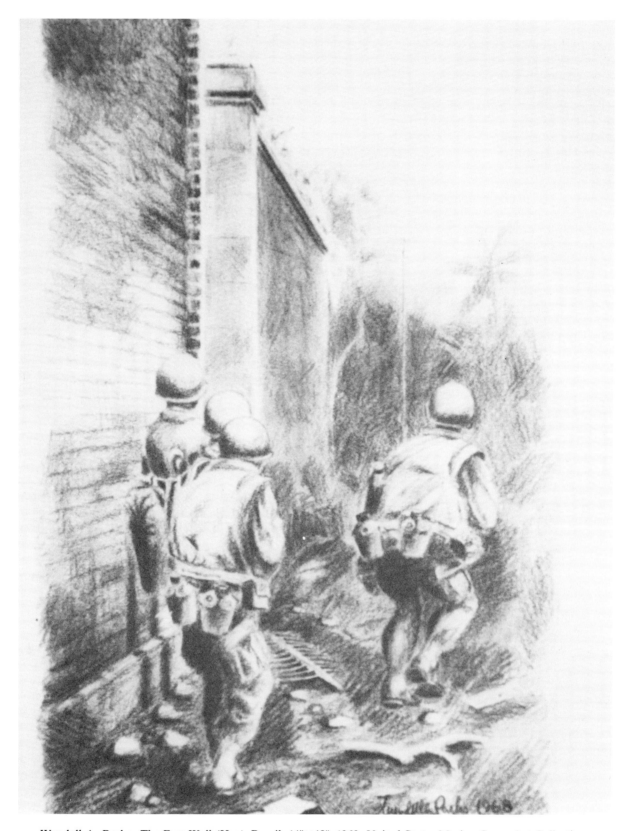

Wendall A. Parks. *The East Wall (Hue)*. Pencil, 14″ × 18″, 1968. United States Marine Corps Art Collection.

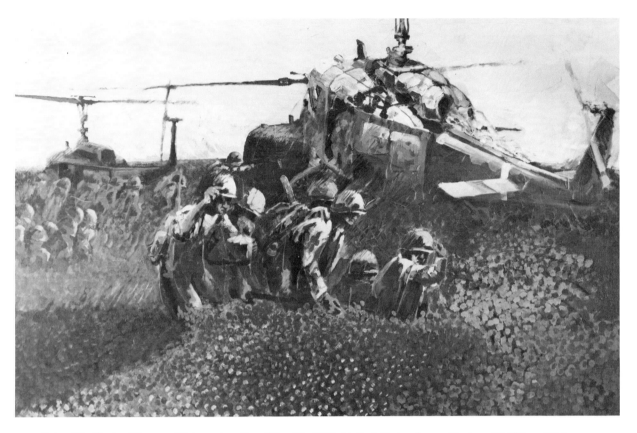

Brian H. Clark. *Chopper Pickup*. Acrylic, 40″ × 40″, 1969. United States Army Center of Military History.

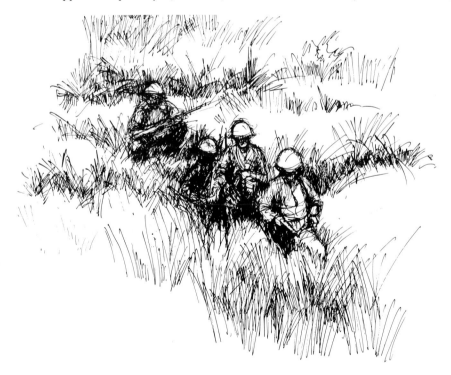

Theodore Abraham. *Checking Out*. Pen and ink, 14″ × 20″, 1967. United States Army Center of Military History.

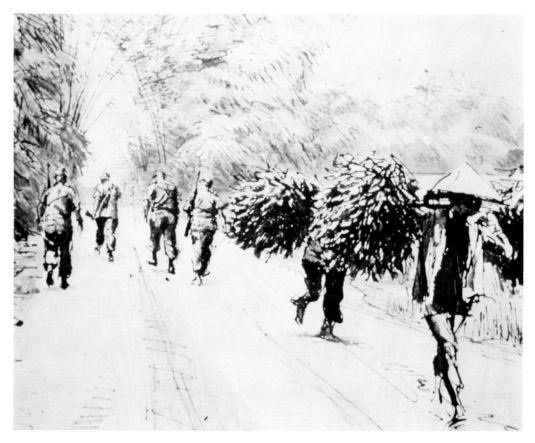

Nick Solovioff. *Marine Patrol.* Pen and ink, 15″ × 21″, 1967. United States Marine Corps Art Collection.

*only to return to riots, bloodshed, despair—
or perhaps hope.*

*Don't speak to him of race. The blood
his brothers shed was real, and not strangely,
was as red as his. When it got down to sur-
vival and life was on the line, colors blended.
After all, color won't stop a well aimed
round.*

*Speak to him of nice things. Scream
about living and life itself. Whisper about
people, love and softness.*

*He is a human being. And, as such,
wants to leave "grunt" and "leg" behind him,
in the dim past, where such history belongs.
His personal victory is simply in terms of
DEROS—leaving Vietnam. He has finished
his one year tour, no more chalking off days
on a calendar. And now his future lies with
his folks, his girl, his job—his world.*

*That world should thank him and let
him go on his way. Give him the respect he*

*merits, but no parades or pedestals, please.
Allow him to pick up the pieces and move on
to a new and fruitful life.*

*As an infantryman, he has earned his
keep, his place out of the sun. He deserved
no less.*

Combat types that saw the most action
included the pointman, a self-made
trailblazer who acted as the eyes and ears of
his company; the "river rats" on river patrol
boats (PBRs) who denied the enemy access to
the waterways, thus slowing their supply
movements; reconnaissance and long-range
patrol members who gathered firsthand in-
telligence on enemy movements and
strengths; and, of course, the "grunt" whose
job, bluntly, was to directly confront the
enemy and kill him.

For Jim Nelson, concern for his buddies
following the Battle of Soui Cut led him to

memorialize the fight in a mural. The result-ing work earned him an invitation to join the army combat art program. Here he describes what happened:

The date was December 22, 1967. I had been assigned to a draftsman position with brigade headquarters after having been in front-line action with Company C of the Second-twenty-second Infantry for three months. But, this first morning on the job, myself and four others were ordered by the first sergeant to report for special duty as-signment.

The five of us were flown by helicopter thirty miles north to the Cambodian border to a small jungle clearing where we were dropped off with our rifles and some picks and shovels, and were told to dig out a com-mand bunker.

I was the only one of the five of us that had had any combat experience. My senses were keen that day, still peaked out from many ambushes, firefights and search-and-de-stroy patrols. I held my breath throughout our day-long picking and shoveling, expecting at any moment to see an enemy squad sweep out of the jungle and rope us in.

Before evening we were lifted out of the clearing. An hour or so later, as it turned out, my old infantry unit, along with the rest of the Third Brigade, moved in with full complements of tanks, armored personnel carriers, weapon carriers and howitzers. Whatever Third Brigade headquarters thought of its almost nonexistent "command bunker" I never learned. But what I did learn was that a force of eight thousand enemy troops had emplaced themselves in the jungle surrounding the clearing sometime before our pick and shovel operation. The minute dark-ness had settled in the area, this immense en-emy force attacked in a human-wave assault.

In the ensuing battle, by extreme and drastic measures such as leveling the howitzer tubes and firing straight out, the first assault was barely repulsed. The second and third were also repulsed as armed helicopters and *cannon-firing planes rushed to the scene. This was the battle of Soui Cut.*

Hearing what had taken place there and being concerned about my buddies in Com-pany C, I hitchhiked a helicopter ride to the clearing. Second-twenty-second and Company C had emerged bloodied but victorious. By morning, the enemy attacks were reduced to spasmodic lobbing of mortar shells. In front of our lines were the piles of enemy corpses where after literally rushing into the cannon's mouth they had been cut down at point blank. Having ascertained that my buddies were all right and after being filled in with the particulars of the battle, I decided to do a mural of it. So, right there, I took out my sketchpad and, aided by my buddies' com-ments, I was able to fill in the still smoking, corpse-strewn, tree-blasted scene that lay be-fore me. I could also draw on my own exper-iences to capture the eerie, remote and almost dreamlike character of the hand-to-hand, face-to-face fighting that had taken place.

Soon after, I had my parents air-express a roll of canvas, paints, brushes and so on, and after working after hours, I completed the mural I envisioned within three weeks. It measures some eight feet by twelve feet. Ac-cording to friends of Company C, it was a remarkable rendition of the actual battle.

After completion of the mural, a divi-sion general who viewed the work recommen-ded me for assignment to the combat artist group of his division. And that is where I ended up. So, even on the battlefield, one might say art has its unexpected rewards.

As a combat artist, I found that transfix-ing the war in oil or watercolor in a timeless way, the various facets of the war and army life in general in Vietnam seemed more bear-able. In fact, it almost seemed enjoyable to me in that I was an individual making a pos-sible contribution to something more signifi-cant than the no-fun, nonheroics of search-and-destroy patrols or by being a draftsman in some sunless, sunken command post, trac-ing troop movements on maps or lettering signs.

Support

It's been said that no army can fight on an empty stomach; thus the need for support and logistics. Without the "gear in the rear" prepared for constant resupply to combat units, setting ground and air objectives would be fruitless.

South Vietnam was divided into four separate support commands: Da Nang, Qui Nhon, Cam Rahn Bay, and Saigon. The commands' support functions included resupplying commodities such as clothing, petroleum products, construction materials, ammunition, medical material, and repair parts; ground and water transportation of cargo; direct and general support of military equipment; and operation and control of shallow-draft ports such as those in Da Nang, Chu Lai and Tan My. The Da Nang support command was in charge of South Vietnam's China Beach R&R Center and of setting the stage every year for the Bob Hope Christmas Show.

The support commands, under the auspices of the United States Army, were the central supply points for the army, navy and marines. The air force maintained their own separate support command in Thailand. It has been estimated that about ninety percent of United States personnel assigned to South Vietnam during the war worked in some type of support command capacity to assist those in combat units.

Aside from logistical support, the combat soldier could also rely on the aid of doctors and nurses, chaplains, cooks, construction engineers, military police, media specialists, reconnaissance pilots and munition loaders, to name a few.

The biggest morale-builders of any soldier were the postal people, who alone were responsible for delivering nearly 200,000 pounds of mail each month and processing $1,500,000 a month in money orders. Mail was considered third priority—behind food and ammunition—but was delivered as regularly as the tactical situation allowed.

The transportation battalions operated the convoys throughout the military regions and furnished units with needed supplies and equipment, including combat-essential items. Class designations determined what type of supplies and services were to be furnished. For example, a Class I operation had the mission of warehousing and issuing rations; Class III operations controlled tank farms and furnished units with petroleum and other industrial gases. There was even a household effects shipping section which handled about forty tons of household goods per month, a field laundry, a bakery supplying three kinds of fresh breads and doughnuts daily, and a self-service supply center.

Engineer detachments furnished maintenance support for heavy equipment operations. Signal detachments supported all countermortar and meteorological radar sets and some communications sites. Ordnance detachments provided ammunition supply and disposal points. Maintenance battalions supplied technicians, mechanics, drivers and cooks, and composite service battalions provided direct support supply and maintenance of all military equipment including the operation of filling stations, washpoints and motor pools.

Chaplains numbered approximately one to every 700 soldiers at any given time during the war. They averaged more than ten services a week, and statistics showed that they reached about seventy-six percent of the

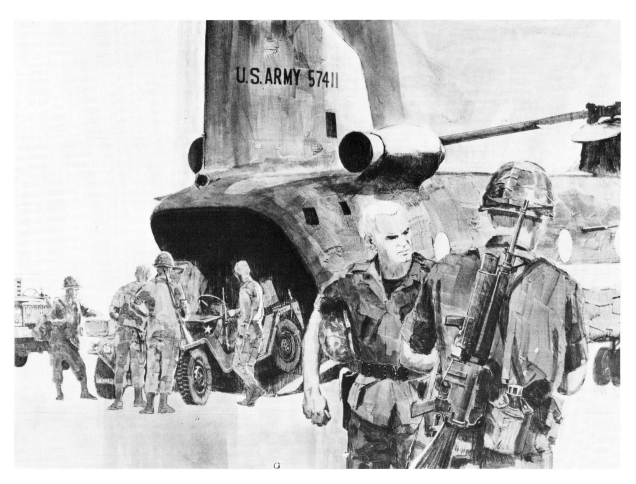

Dennis O. McGee. *Jolly Green Giant*. Acrylic, 28″ × 40″, 1967. United States Army Center of Military History.

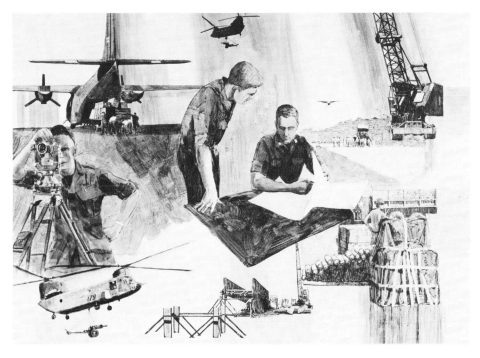

Dennis O. McGee. *Composite Painting*. Acrylic, 30″ × 40″, 1967. United States Army Center of Military History.

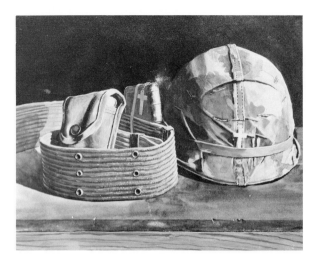

Stephen H. Sheldon. *Painting of a Chaplain's Helmet and Gear.* Watercolor, 16″ × 20″, 1966. United States Army Center of Military History.

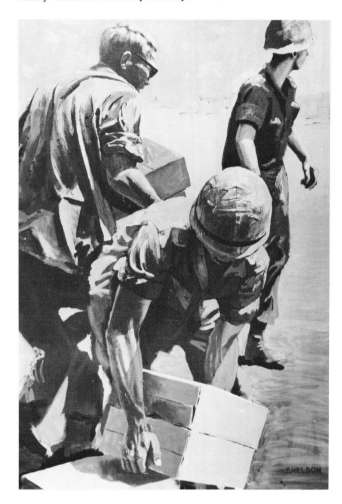

Stephen H. Sheldon. *Resupply.* Oil, 34″ × 24″, 1967. United States Army Center of Military History.

people in their command. More than 2,000 chaplains served in South Vietnam. Less than a dozen were casualties and three were awarded the Medal of Honor.

The most critical support of the war came from members of the medical teams. From the medic or corpsman in the field, to the pilots of medical evacuation helicopters, to the surgeons and nurses at base hospitals, their iron dedication and bravery helped save lives. Medics and corpsmen suffered heavy casualties while tending to the wounded during the heat of battle. Their chief concern was to continually supply immediate aid despite all odds. Marine artist Henry Casselli, a former corporal in Vietnam, had a eulogy in his sketch *Corpsman* that states: "A corpsman is often labeled 'Doc.' He is everyone's friend, especially when the going gets tough. He not only gives physical aid but ofttimes a spiritual boost."

Medevac pilots landed in the middle of firefights to pluck the wounded out and deliver them to the nearest aid station, usually within fifteen minutes of being summoned; medevac helicopters, usually AH1 Hueys with two pilots, mechanic, medic, and room for six wounded, were shot down fifty percent more often than combat helicopters.

Doctors and nurses at mobile army support and evacuation hospitals and city hospitals in Saigon helped reduce the casualty rate: In World War II, of every three men hit, one died, whereas during the Vietnam War, deaths were one out of five, despite the use of higher-velocity weapons.

The army animal clinic at Ton Son Nhut Air Base in Saigon treated injured scout and patrol dogs much the same way humans were. Even medical records for the dogs, primarily German shepherds, were kept up-to-date. The patrol dogs assisted military policemen in maintaining perimeter security around bases. The scout dogs were used to detect ambush sites and enemy weapon and food caches.

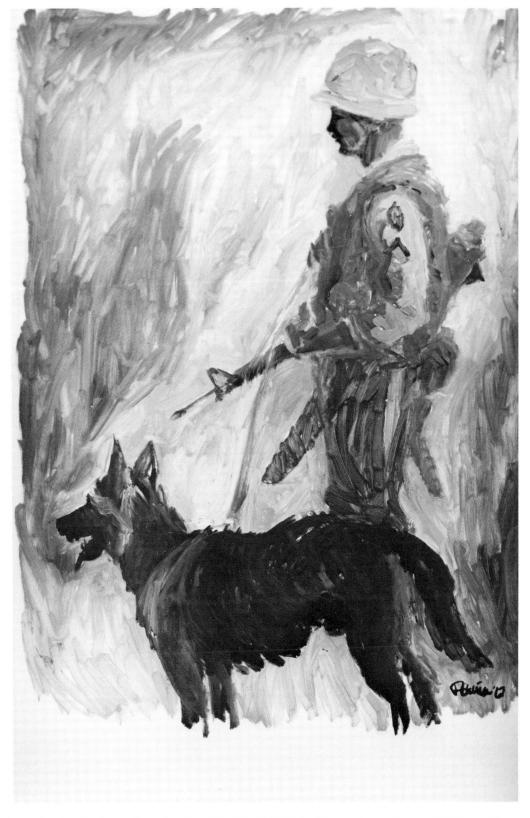

Augustina Acuña. *Scout Dog*. Acrylic, 40″×30″, 1966. United States Army Center of Military History.

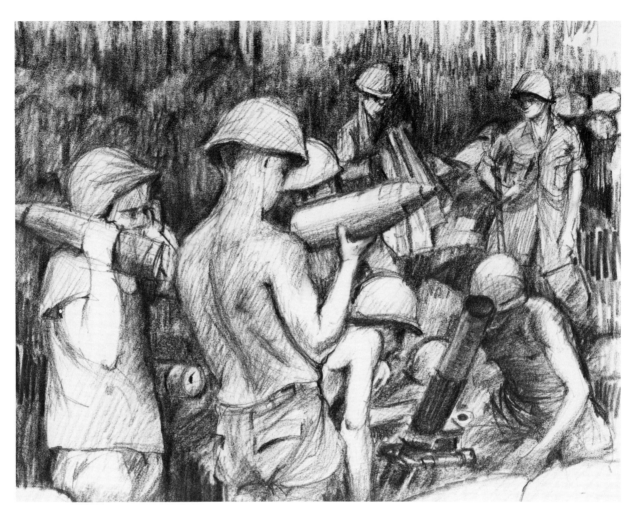

Theodore Abraham. *Coming Up*. Pen, 11″×14″, 1967. United States Army Center of Military History.

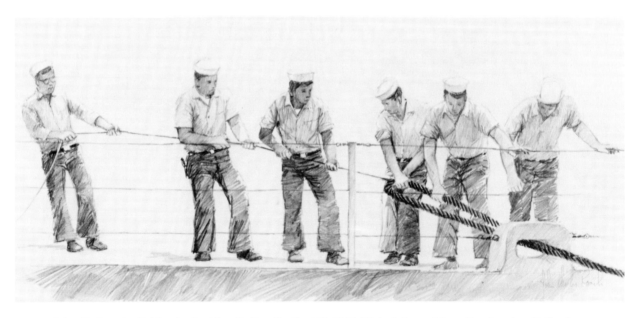

John C. Roach. *Taking in the Line* #1. Pencil, 6″×15″, 1969. United States Navy Combat Art Collection.

Dennis O. McGee. *Repairing Mine Damage*. Watercolor, 1967. United States Army Center of Military History.

Bruce N. Rigby. *SP 155 Howitzer*. Acrylic, 18″ × 24″, 1969. United States Army Center of Military History.

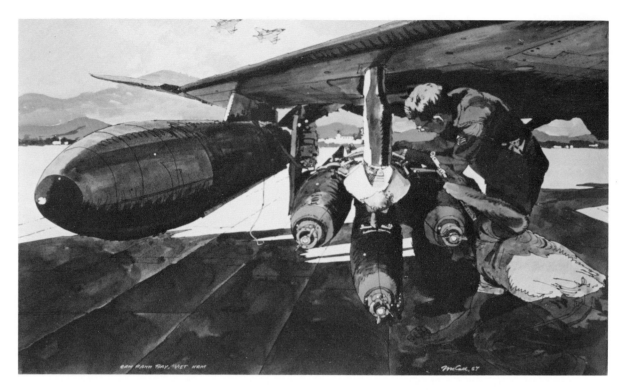

Robert T. McCall. *Cam Rahn Bay*. ACR, 60″ × 48″, 1967. United States Air Force Art Collection.

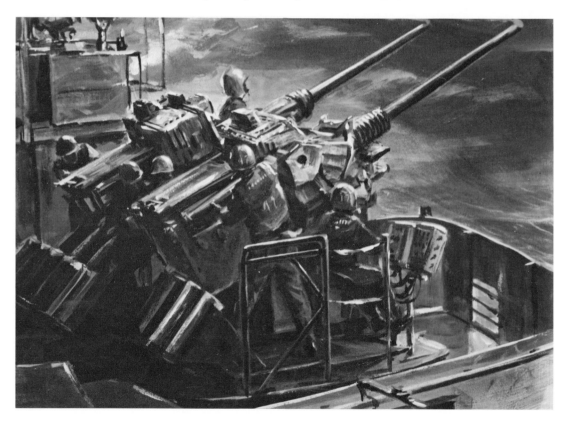

John Steel. *Pre-Landing Naval Bombardment*. Acrylic, 10″ × 14″, 1966. United States Navy Combat Art Collection.

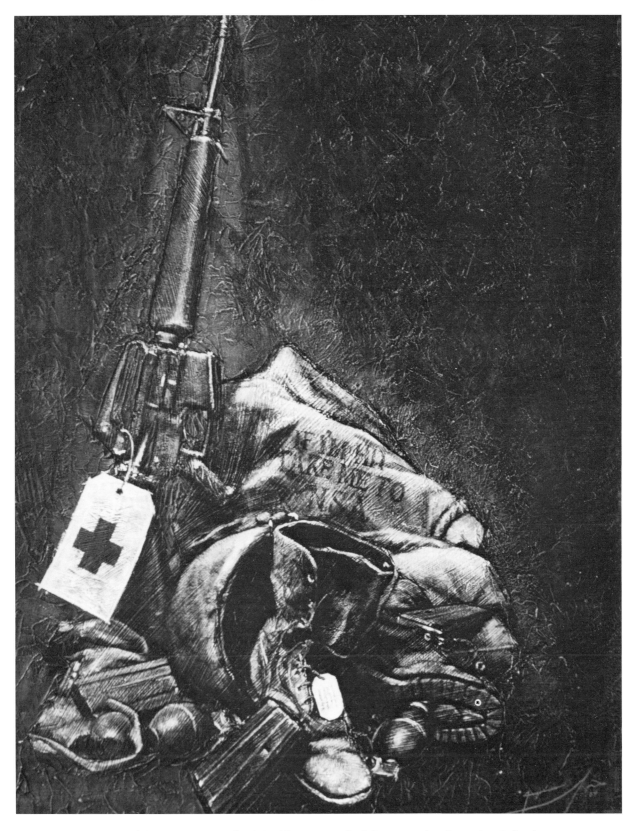

James Fairfax. *Triage*. Acrylic, 25″ × 33″, 1969. United States Marine Corps Art Collection.

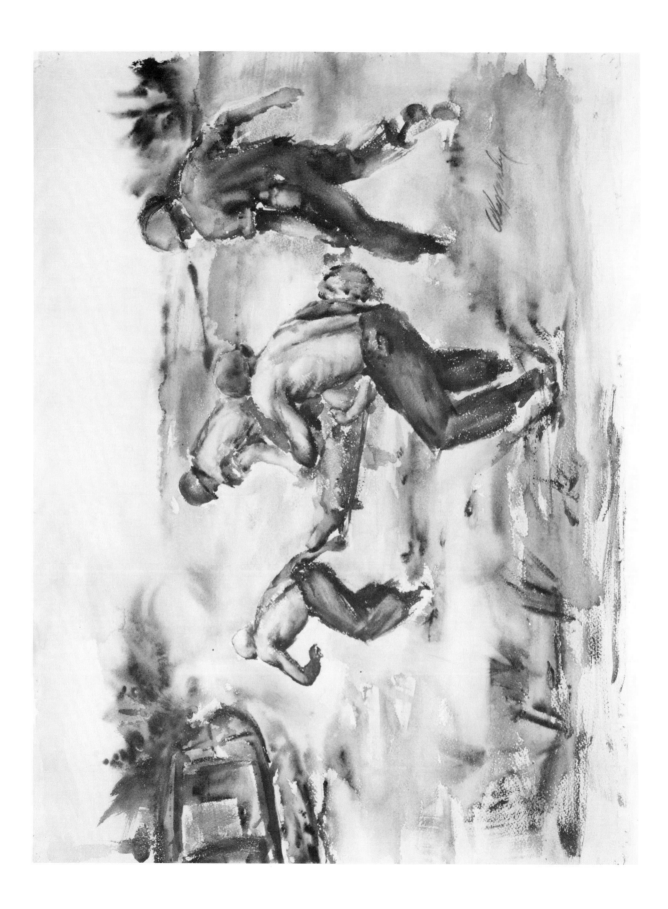

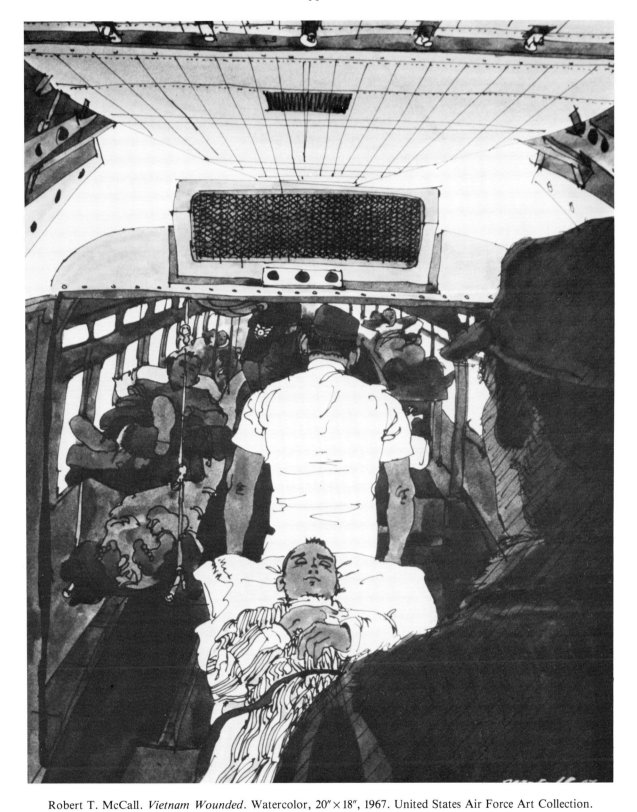

Robert T. McCall. *Vietnam Wounded*. Watercolor, 20″ × 18″, 1967. United States Air Force Art Collection.

Opposite: Samuel E. Alexander. *Dust Off*. Watercolor, 22″ × 30″, 1967. United States Army Center of Military History.

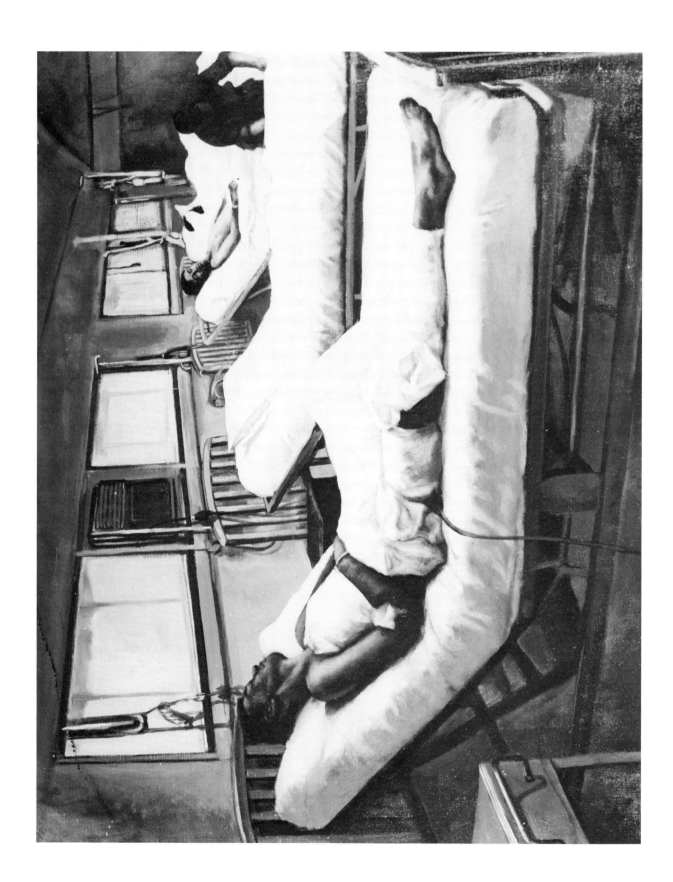

John T. Dyer. *USO, Da Nang, Vietnam*. Watercolor, 10″ × 13″, 1966. United States Marine Corps Art Collection.

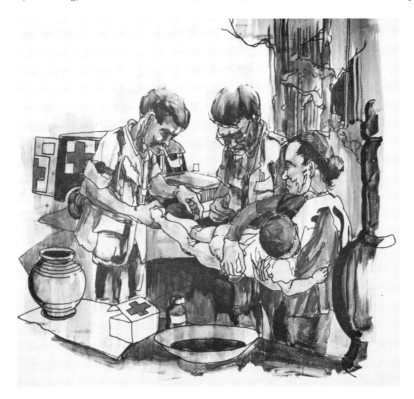

Stephen H. Randall. *Two Medics*. Watercolor, 11″ × 11″, 1968. United States Army Center of Military History.

Opposite: John D. Kurtz. *Intensive Care Ward*. Oil, 32″ × 40″, 1967. United States Army Center of Military History.

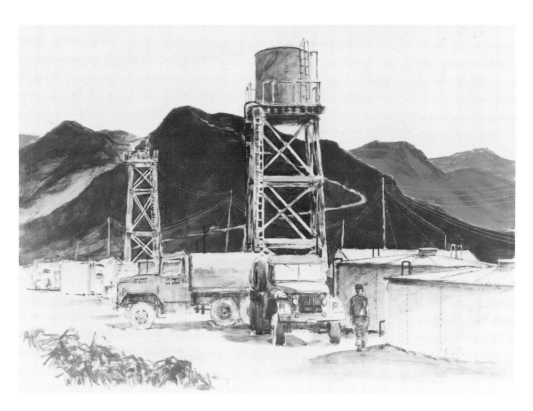

John C. Roach. *City Waterworks, Camp Haskins*. Acrylic, 22″ × 30″, 1969. United States Navy Combat Art Collection.

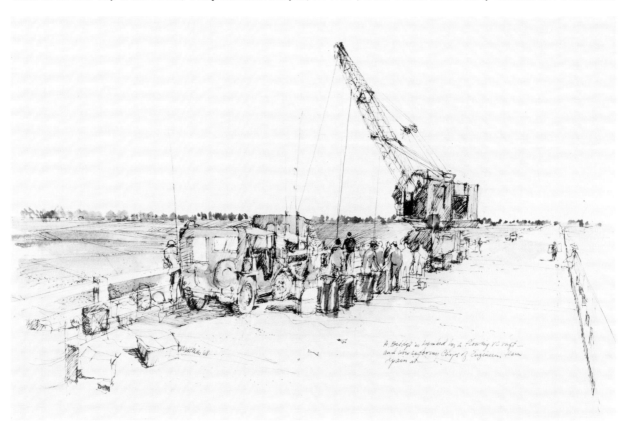

Stephen Matthias. *Bridge Repair*. Watercolor, 22″ × 38″, 1968. United States Army Center of Military History.

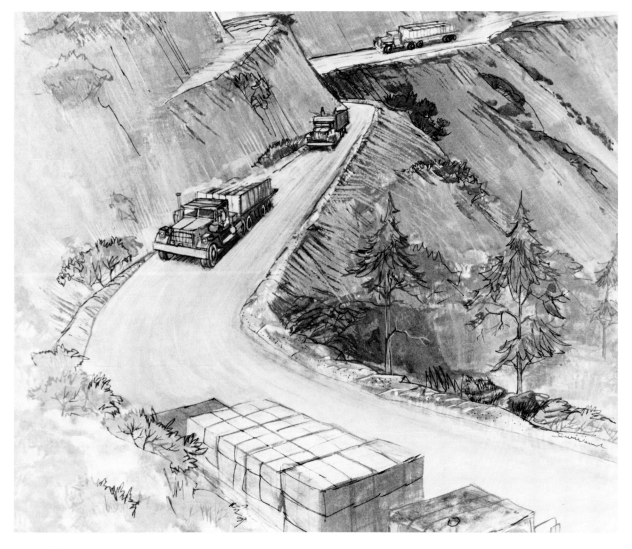

E.C. Williams. *Convoy on the Mang Yang Pass*. Ink and acrylic, 15″ × 18″, 1969. United States Army Center of Military History.

Many artists recognized the importance of the support function in Vietnam. For those artists that portrayed this facet of the war, many noted that the people they portrayed were thankful for the recognition of their support in a common cause.

Air War

Prior to the Tonkin Gulf incident, aircraft missions in Vietnam were limited to unarmed RF-8A Photo Crusader reconnaissance flights, helicopter search-and-rescue (SAR) operations and helicopter troop and cargo lifts of South Vietnamese soldiers. Several pilots were shot down during this period; a few were never found.

Following the Tonkin Gulf defensive, jet fighters such as F-8 Crusaders, A-4 Skyhawks and A-1 Skyraiders were mission-utilized for the first time in offensive strikes. It was during these attacks on North Vietnamese ports and bases that navy lieutenant (j.g.) Everett Alvarez became the first United States prisoner-of-war in Vietnam when his A-4 was shot down over Hon Gai.

Six months would pass before aircraft would once again take a leading role in Vietnam. On March 2, 1965, one of the longest and most controversial series of bombing missions of the war began operations. Code-named ROLLING THUNDER, the missions were comprised of bombing strikes aimed at strategic military and industrial targets inside North Vietnam. ROLLING THUNDER continued operations for nearly eight years. Two million tons of bombs were dropped in over a quarter of a million missions, and nearly 1,000 United States aircraft were lost.

Navy attack and fighter squadrons during Vietnam were based within aircraft carrier groups. Two strategic points in the Tonkin Gulf, Yankee Station off Da Nang and Dixie Station off Saigon, were selected as permanent stations for carriers such as the *Enterprise, Constellation, Hancock* and *Coral Sea.* The air force maintained their B-52 bomber base in Thailand while supporting their other squadrons in South Vietnam at air bases such as the one at Bien Hoa near Saigon. Meanwhile, the Marine Corps established their ground-support operations at the airfield they built at Chu Lai near Da Nang.

Aside from attack- and fighter-type planes utilized by the navy, air force and marines and the air force's heavy bombers, other types of fixed-wing aircraft in Vietnam included transport and cargo planes for moving troops and supplies—for C-123 cargo transports, spraying defoliants—and various other prop-types used primarily for reconnaissance missions. However, it was the helicopter that proved to be the most invaluable source of support from the skies. Utilized for carrying troops and supplies to remote areas of the war and for providing close air support, the helicopter as an ambulance greatly reduced the casualty rate of combat soldiers as compared to the mortality rate of previous wars.

For the combat artists, achieving an accurate representation of aircraft operations in Vietnam was among their most challenging assignments. Flying aboard a jet aircraft was inconceivable, so artists had to rely heavily on interviews with airmen and ensuing mission photographs in order to give their paintings and sketches proper settings. Air force artist Keith Ferris spent four months creating *Doumer Bridge* after researching facts on formations, approach tactics and forces of gravity.

Artists accompanying helicopter and transport crews on missions often found themselves amazed at the beautiful and seemingly tranquil environment of South Vietnam as seen from the air—only to have the air around them explode with danger within seconds.

All told, more than 37,000 American aircraft (not including helicopters) were destroyed during the Vietnam War, claiming over 8,000 air crew lives. Air force artist Maxine McCaffrey portrayed these dismal statistics in her painting *He Radioed* (p. 54).

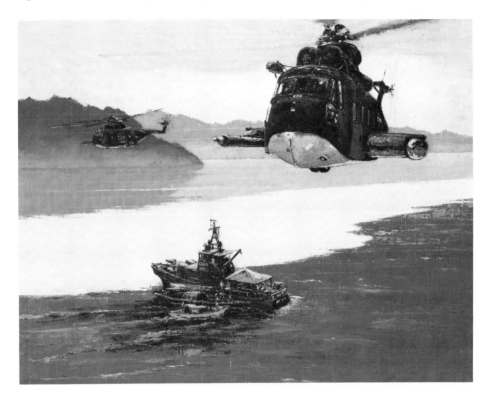

Noel Daggett. *Returning to Da Nang from DMZ at Dusk.* Oil, 1967. United States Coast Guard Art Collection.

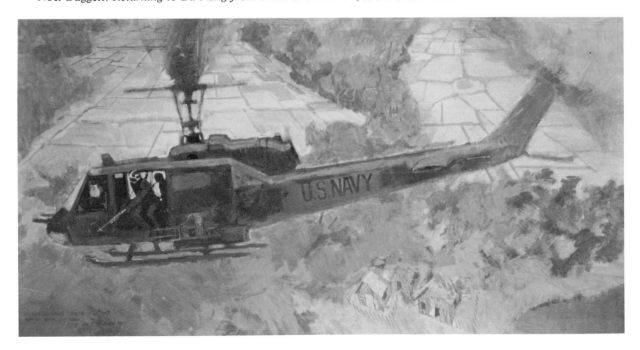

Marbury H. Brown. *Seawolves Ignore VC Bait.* Oil, 22″×28″, 1967. United States Navy Combat Art Collection.

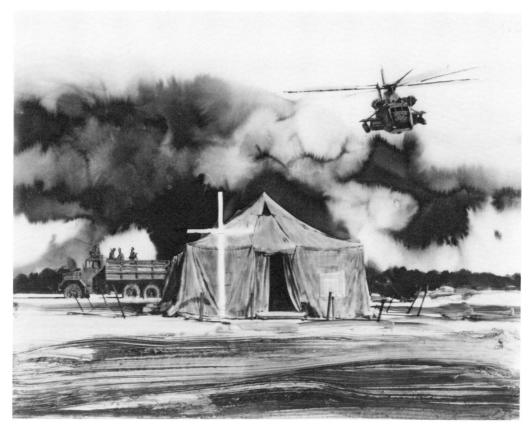

Joseph Cleary. *Christmas Day at Quang Tri*. Acrylic, 20″ × 35″, 1967. United States Air Force Art Collection.

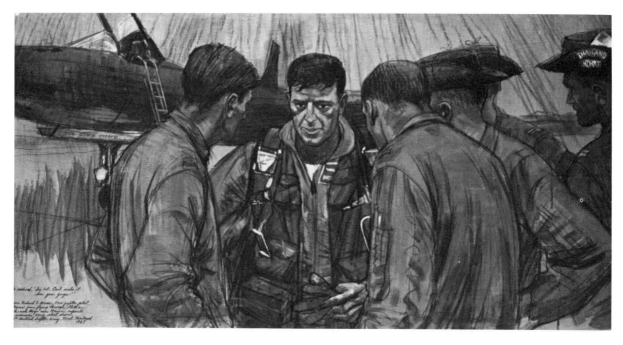

Maxine McCaffrey. *He Radioed, "I'm Hit . . . Can't Make It . . . See You Guys."* Acrylic, 48″ × 40″, 1967. United States Air Force Art Collection.

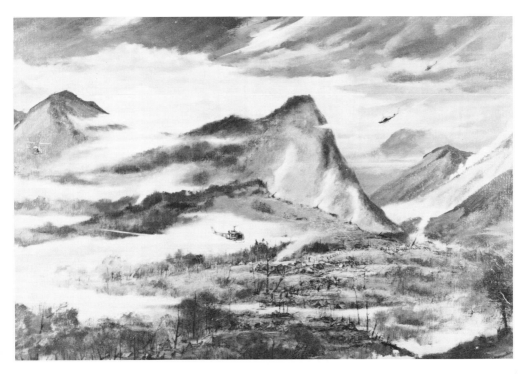

John Wheat. *Bringing Them In*. Acrylic, 28″ × 48″, 1968. United States Army Center of Military History.

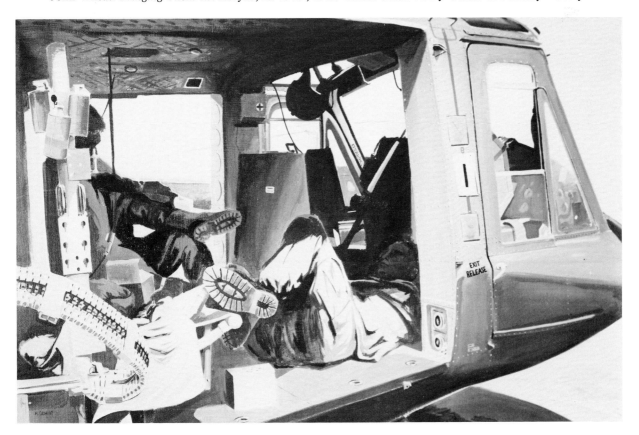

Michael R. Crook. *C's and Siesta*. Acrylic, 24″ × 36″, 1967. United States Army Center of Military History.

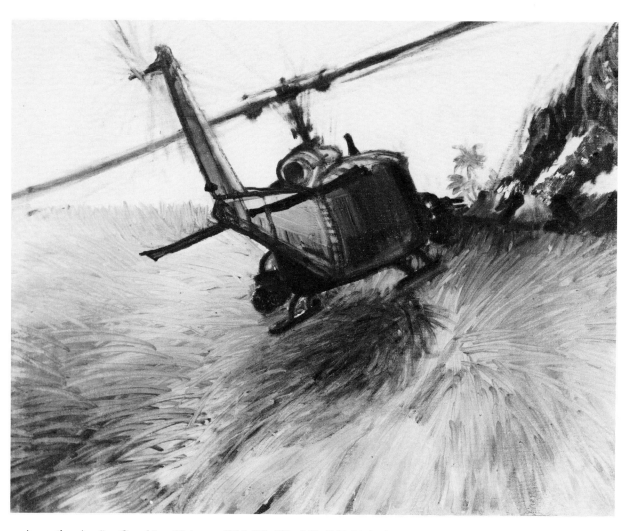

Augustine Acuña. *Gunship—Vietnam, 1966.* Oil, 18″×24″, 1966. United States Army Center of Military History.

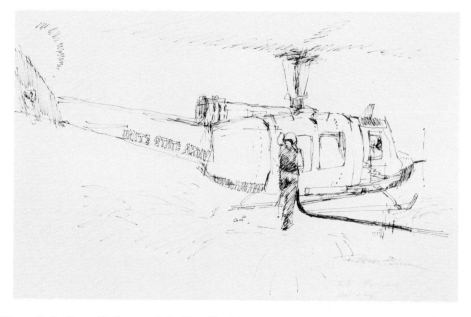

Roger Blum. *Refueling a Helicopter.* Ink, 9″×12″, 1966. United States Army Center of Military History.

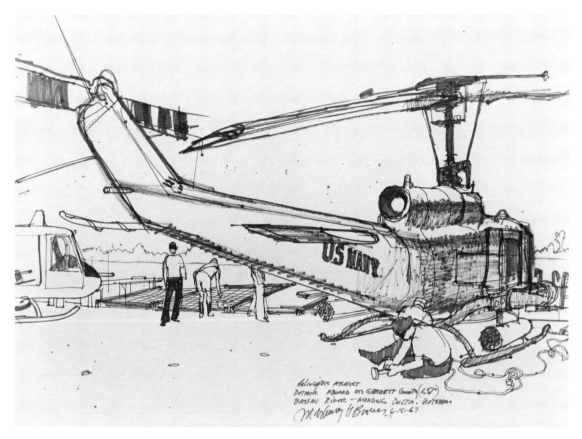

Marbury H. Brown. *Aboard USS* Garrett County. Felt pen, 18″ × 23″, 1967. United States Navy Combat Art Collection.

Theodore Abraham. *Air Lift*. Pen and ink, 13″ × 18″, 1967. United States Army Center of Military History.

Dennis O. McGee. *Chinook Resupply*. Felt pen, 18″ × 12″, 1967. United States Army Center of Military History.

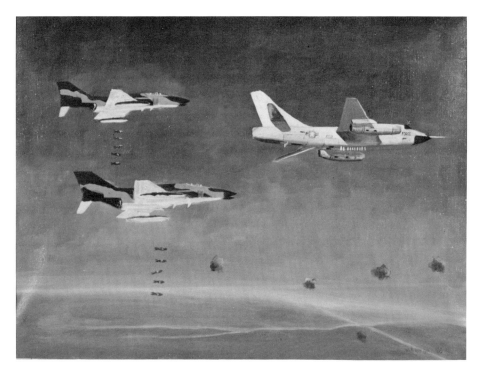

W.R. Roche. *Untitled*. Acrylic, 42″×72″, 1973. United States Air Force Art Collection.

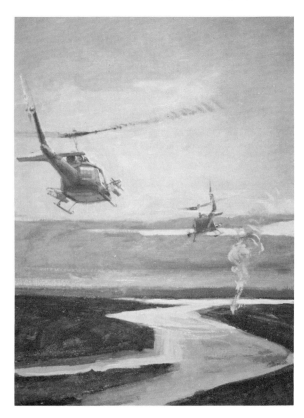

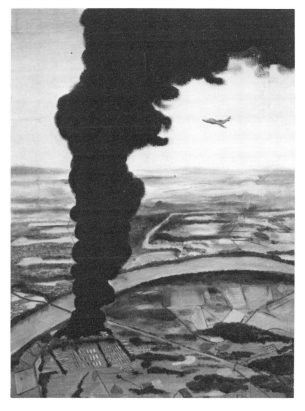

John Scott. *Seawolves over the Delta*. Oil, 30″×24″, 1969. United States Navy Combat Art Collection.

Artist unknown. *Untitled*. Watercolor, 19″×24″. United States Air Force Art Collection.

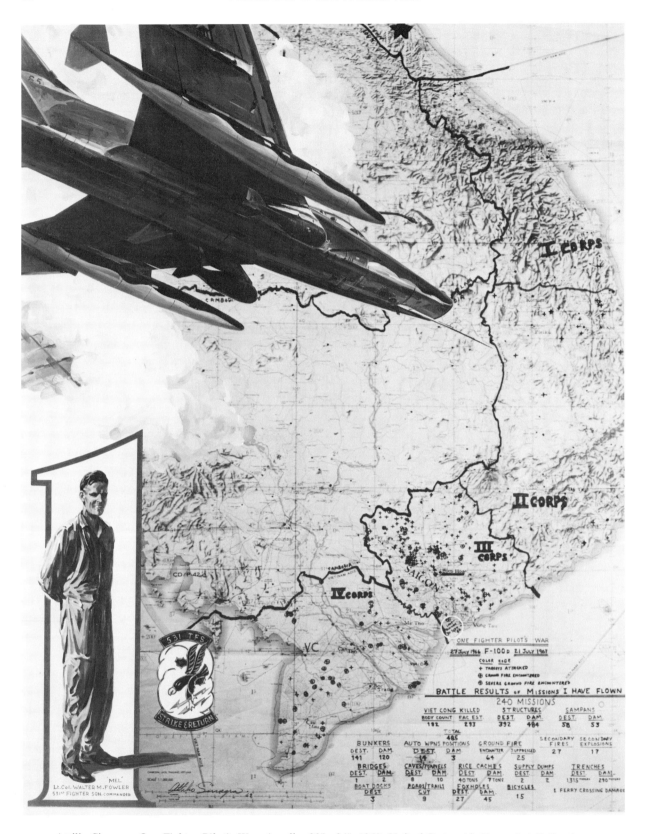

Attilio Sinagra. *One Fighter Pilot's War*. Acrylic, 30″ × 24″, 1969. United States Air Force Art Collection.

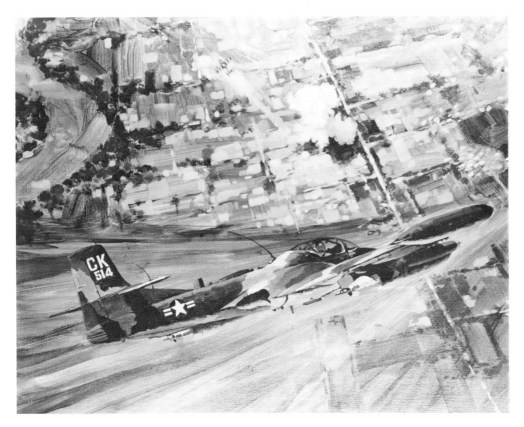

George Akimoto. *A-37 Mission from Bien Hoa*. Acrylic, 52″ × 42″, 1969. United States Air Force Art Collection.

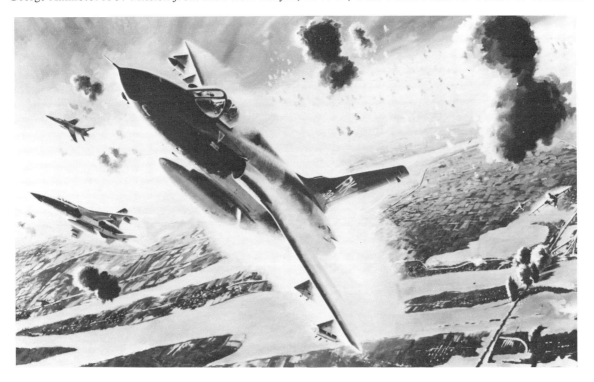

Keith Ferris. *Doumer Bridge*. Oil, 72″ × 48″, 1977. United States Air Force Art Collection.

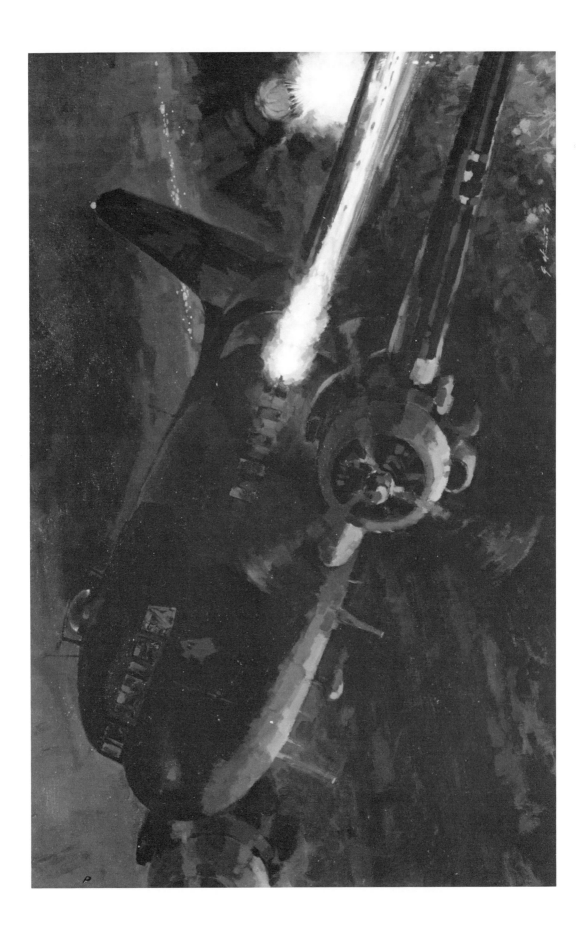

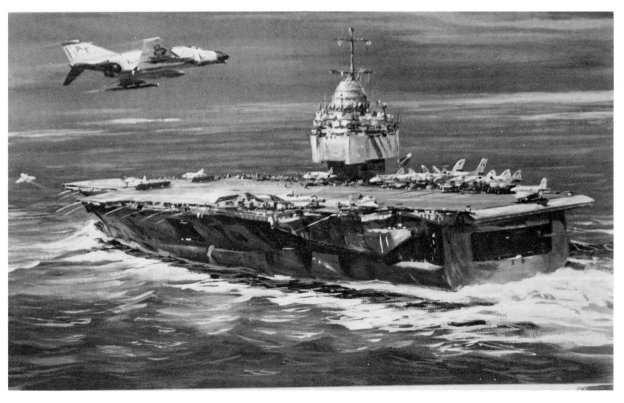

John Steel. *Enterprise on Yankee Station*. Acrylic, 12″ × 21″, 1966. United States Navy Combart Art Collection.

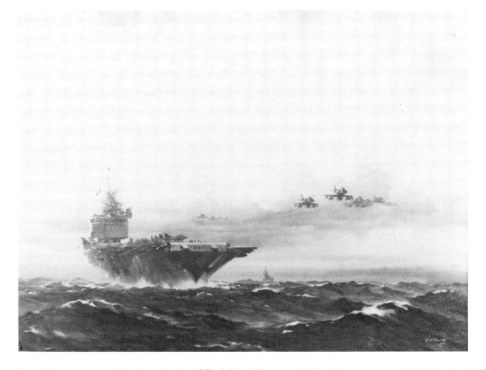

R.G. Smith. *Enterprise on Yankee Station*. Oil, 36″ × 44″, 1969. United States Navy Combat Art Collection.

Opposite: George Akimoto. *AC-47 Spooky Mission Near Saigon*. Acrylic, 36″ × 30″, 1969. United States Air Force Art Collection.

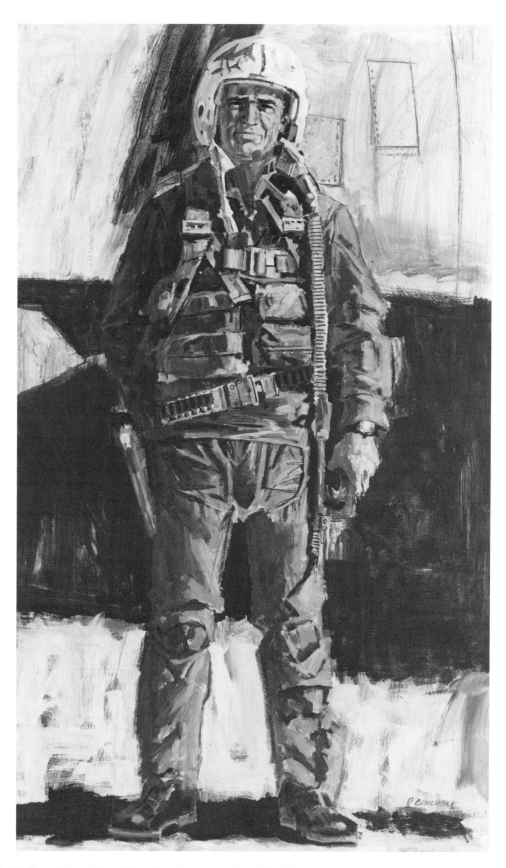

Gus Colichidas. *Colonel Randall—Phan Rang*. Acrylic, 54″ × 32″, 1967. United States Air Force Art Collection.

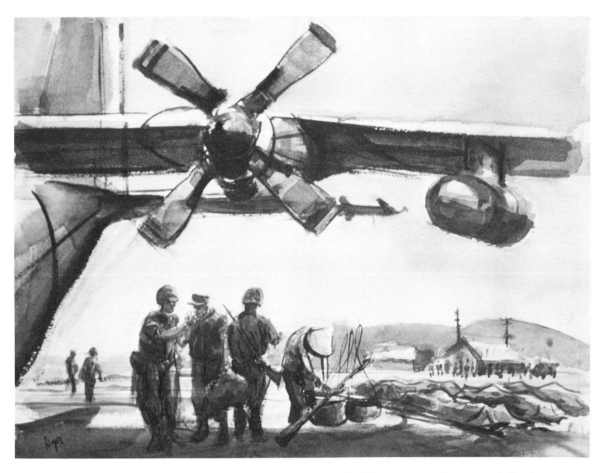

John T. Dyer. *Da Nang*. Watercolor, 18″×24″, 1966. United States Marine Corps Art Collection.

Portraits

Having the responsibility of covering a war does not necessarily mean involving oneself in the thick of the action. Combat artists of the Vietnam War, as observers, have astutely recorded moments that will never find their way into history books, but nonetheless are just as important and reflect the war just as clearly as any battle. These are the renditions of the private moments of war: the reading of a letter from home, the holding of a wounded buddy until doctors can treat him, the quiet meditating in a field church, or the waiting for word of a friend or unit out in the bush. These too are visions of the feelings of war that, for the subjects, may carry the pain beyond the battlefield.

Then there are the portraits: the casual observance of a soldier in full combat regalia awaiting orders to move out, the orphan child, the hard-nosed "gunny," the papa san, or the wounded GI. These portraits were of the faces in the crowd, most of them unknown to each other, yet all sharing in the same cause.

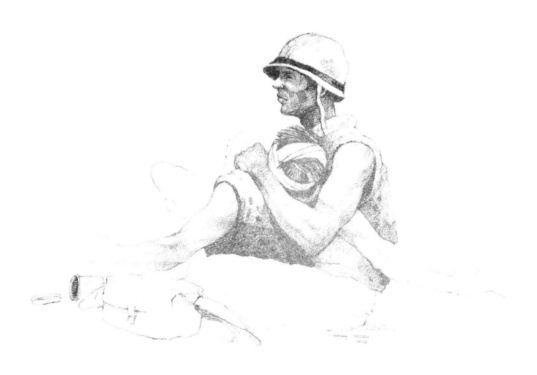

Henry Casselli. *Corpsman*. Pencil, 22″ × 28″, 1968. United States Marine Corps Art Collection.

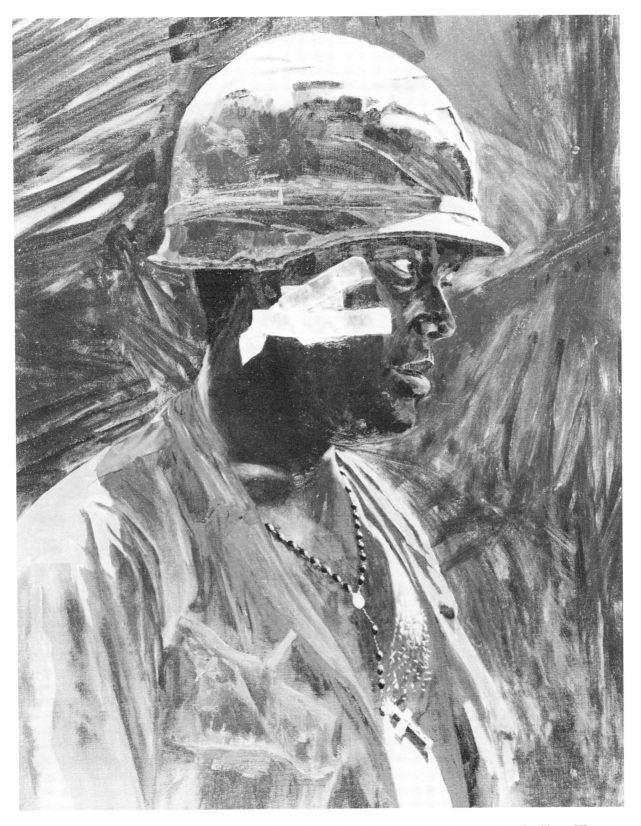

Stephen H. Sheldon. *Cavalry Trooper*. Watercolor, 16″×19″, 1967. United States Army Center of Military History.

Victory Von Reynolds. *Riding Back from Patrol*. Oil, 48″×54″, 1969. United States Army Center of Military History.

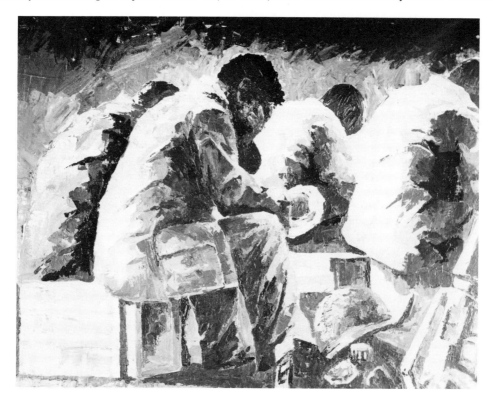

Michael R. Crook. *Easter Sunrise*. Acrylic, 28″×24″, 1967. United States Army Center of Military History.

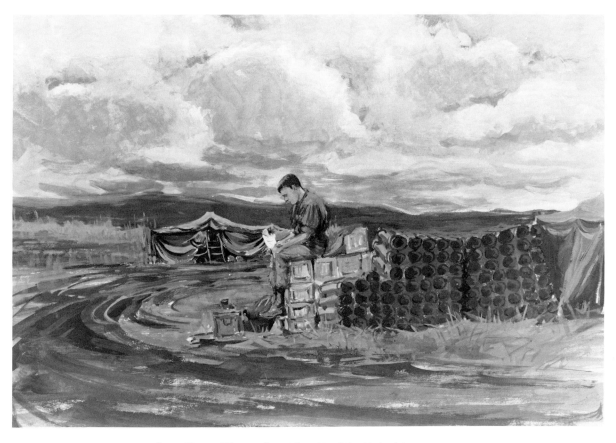

Theodore Abraham. *Letter from Home*. Watercolor, 11″ × 14″, 1967. United States Army Center of Military History.

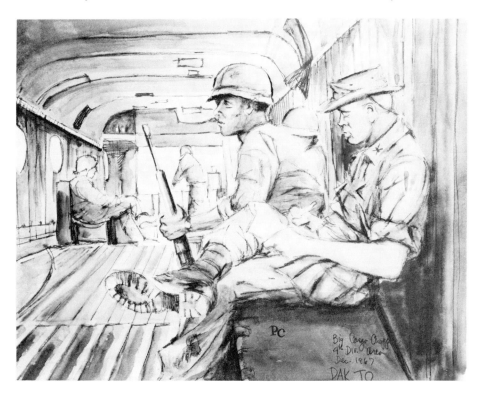

Peter Copeland. *Inside a Big Cargo Chopper*. Watercolor, 11″ × 14″, 1967. United States Army Center of Military History

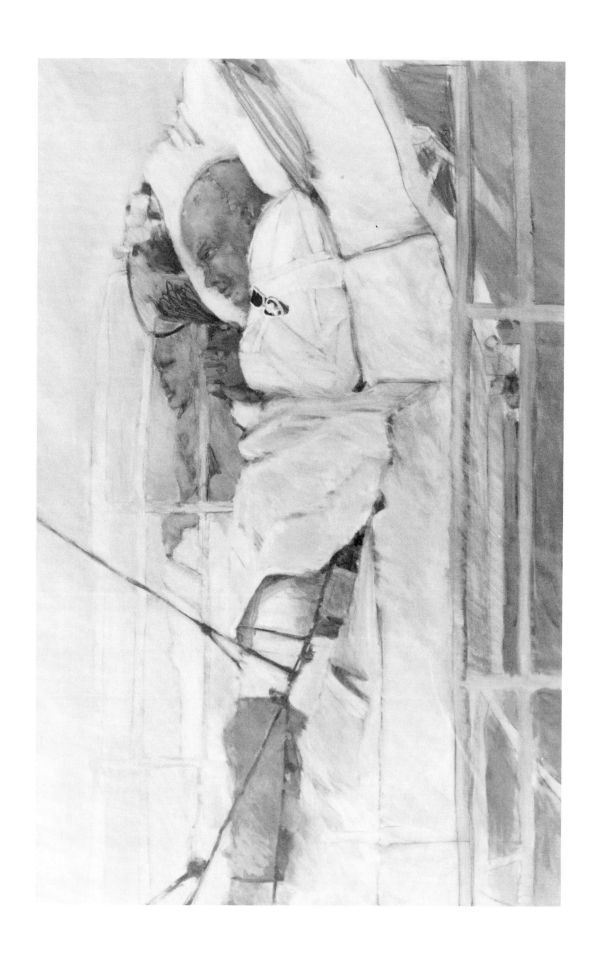

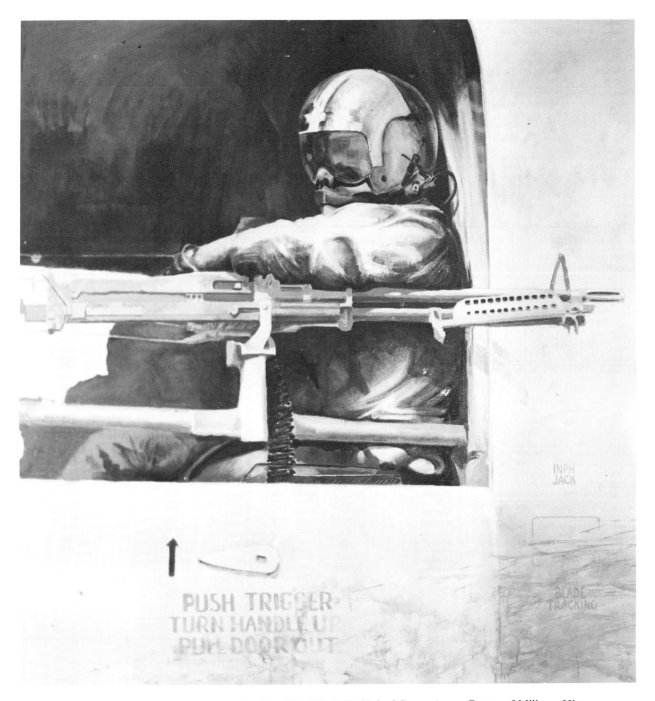

Brian H. Clark. *Chinook Gunner*. Acrylic, 40″ × 40″, 1968. United States Army Center of Military History.

Opposite: John Wehrle. *Purple Heart*. Oil, 36″ × 46″, 1966. United States Army Center of Military History.

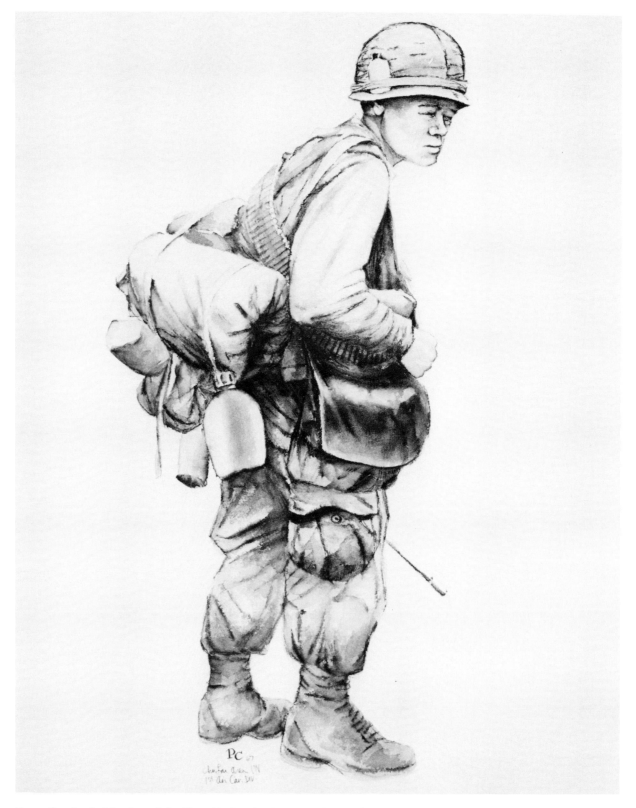

Peter Copeland. *Member of the First Air Cavalry Division*. Watercolor, 30″ × 21″, 1967. United States Army Center of Military History.

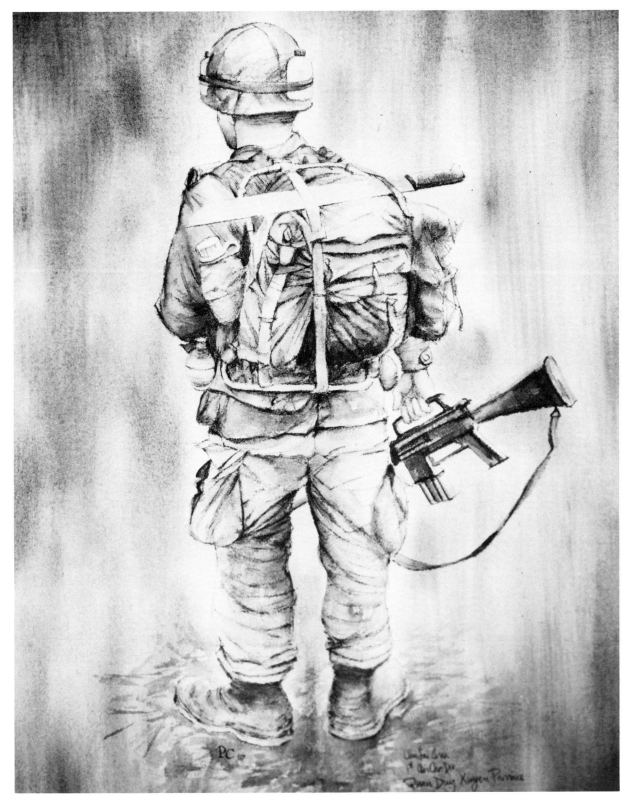

Peter Copeland. *Member of the First Air Cavalry Division with His Combat Load.* Watercolor, 14″ × 11″, 1967. United States Army Center of Military History.

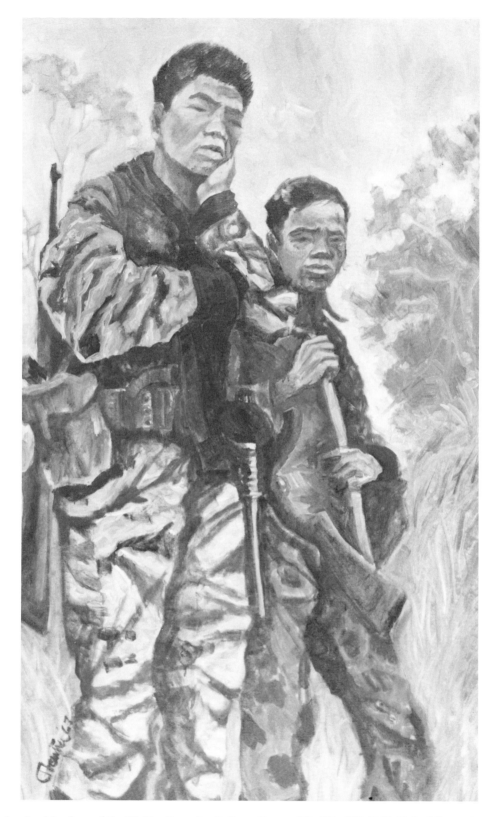

Augustine Acuña. *Members of the Civilian Irregular Defense Group*. Oil, 52″ × 32″, 1967. United States Army Center of Military History.

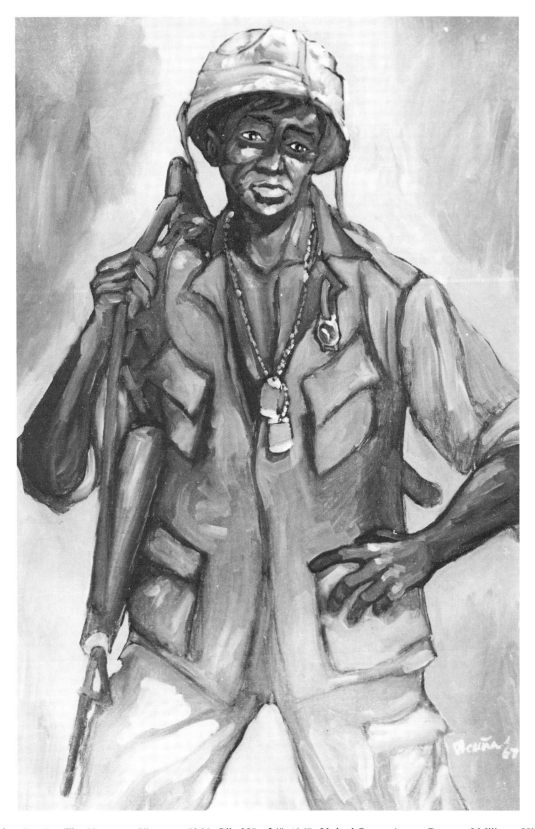

Augustine Acuña. *The Veteran—Vietnam, 1966*. Oil, 38″×24″, 1967. United States Army Center of Military History.

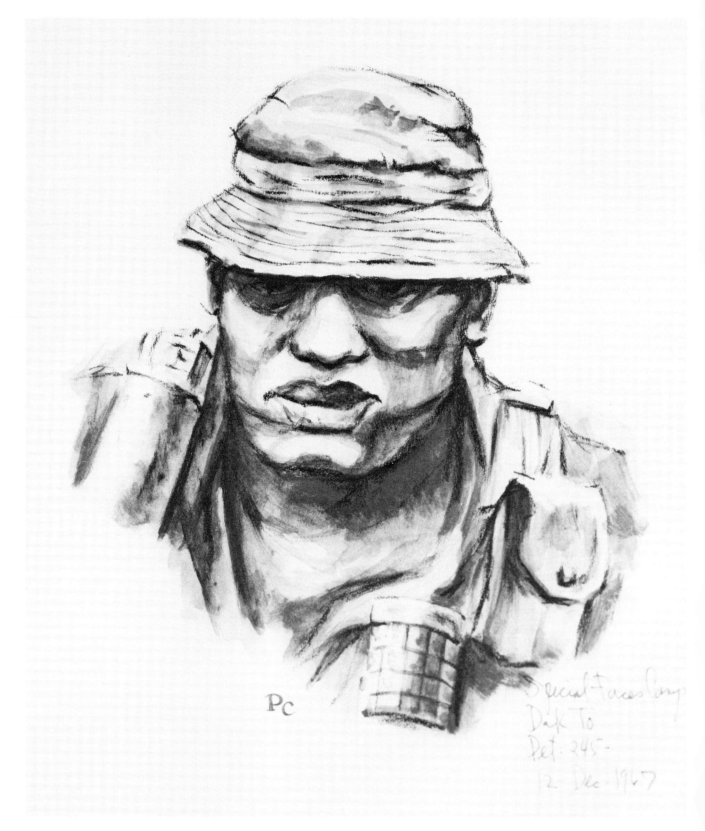

Peter Copeland. *Member of Special Forces*. Watercolor, 14″ × 11″, 1967. United States Army Center of Military History.

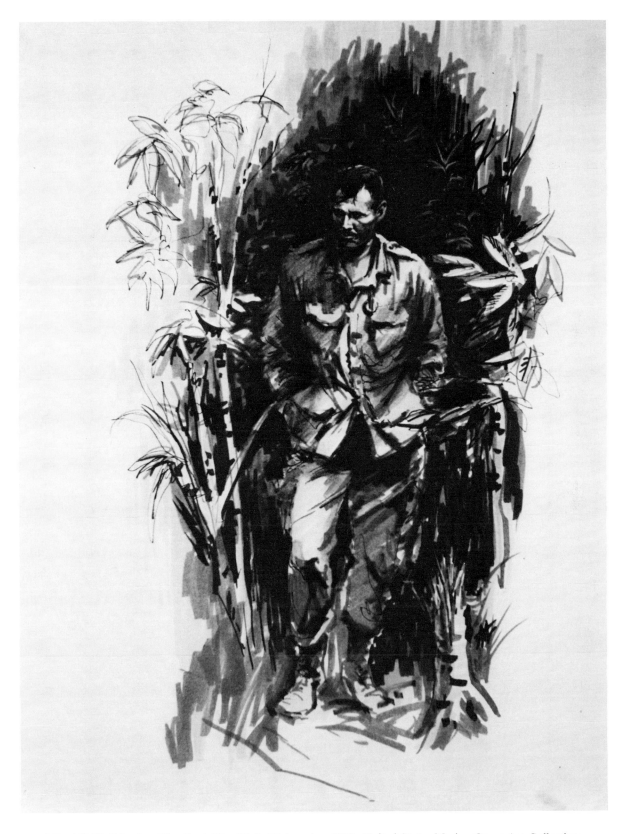

Albert "Mike" Leahy. *The Cost Was High*. Watercolor, 1967. United States Marine Corps Art Collection.

Peter Copeland. *Military Potpourri*. Ink and watercolor, 14″×11″, 1967. United States Army Center of Military History.

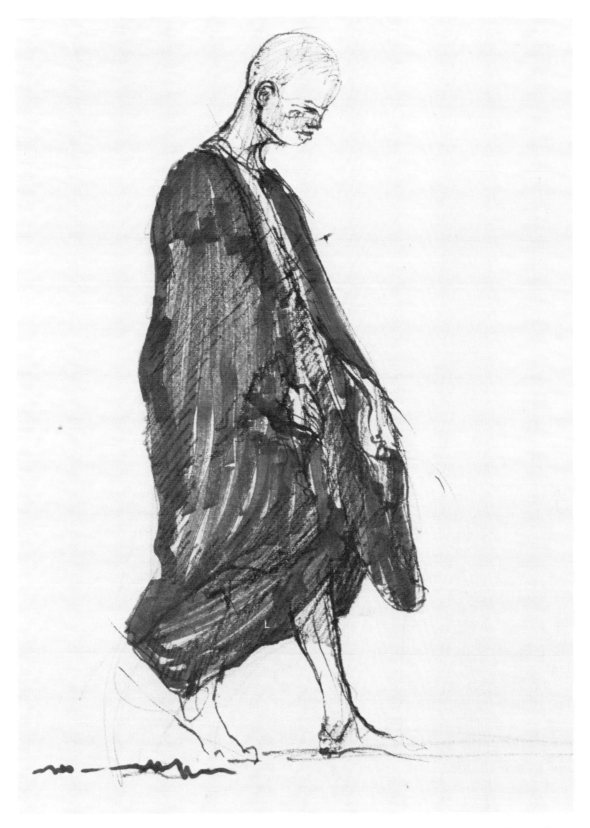

Gerald W. Dokken. *Monk*. Ink and watercolor, 6″ × 11″, 1970. United States Army Center of Military History.

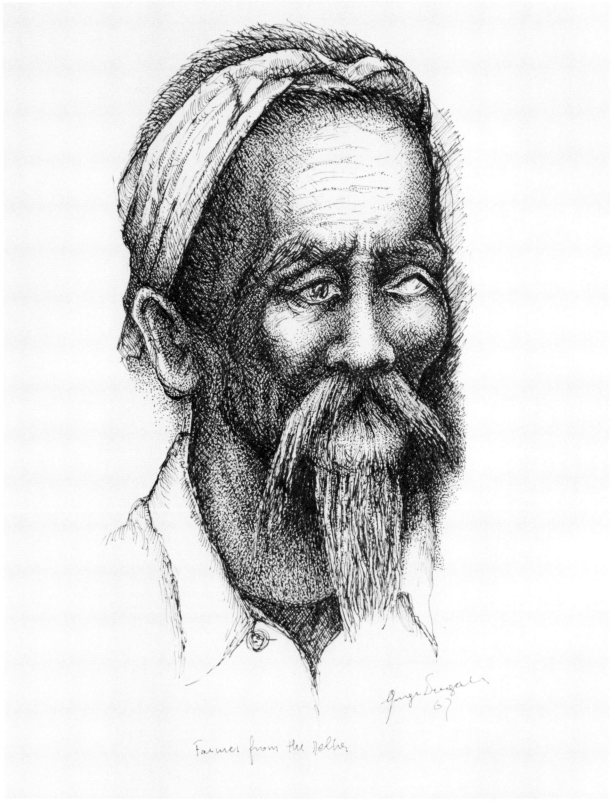

George Dergalis. *Farmer from the Delta*. Ink, 10″×13″, 1967. United States Army Center of Military History.

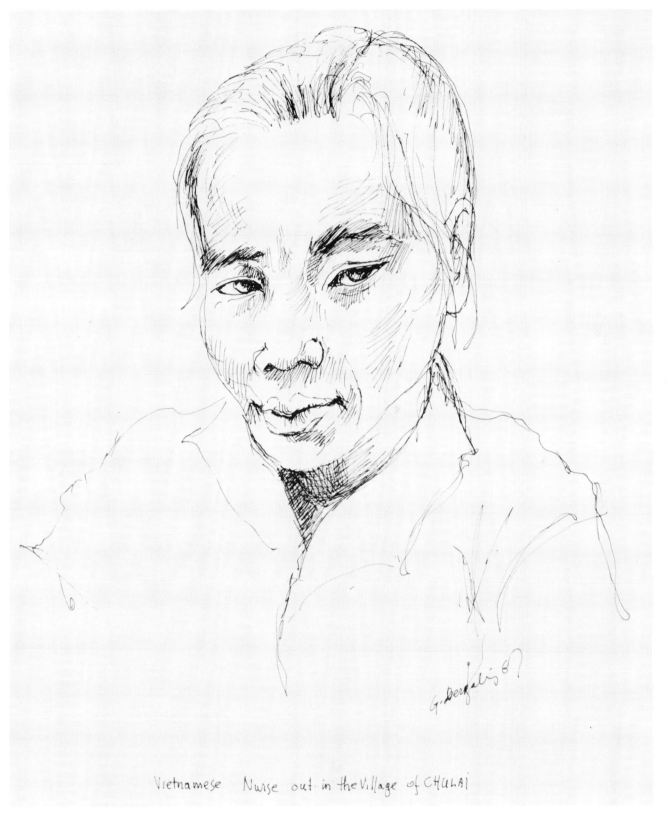

Vietnamese Nurse out in the Village of CHULAI

George Dergalis. *Vietnamese Nurse*. Ink, 10″×13″, 1967. United States Army Center of Military History.

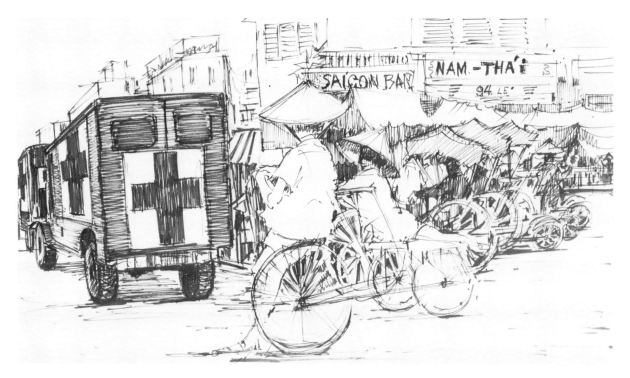

Theodore Abraham. *Traffic Watcher*. Felt pen, 13″×20″, 1967. United States Army Center of Military History.

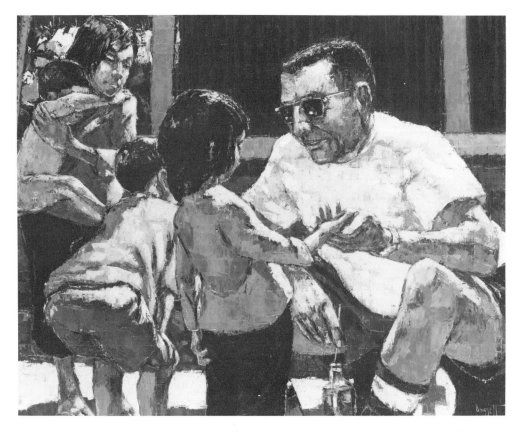

Noel Daggett. *This Won't Hurt a Bit*. Oil, 1967. United States Coast Guard Art Collection.

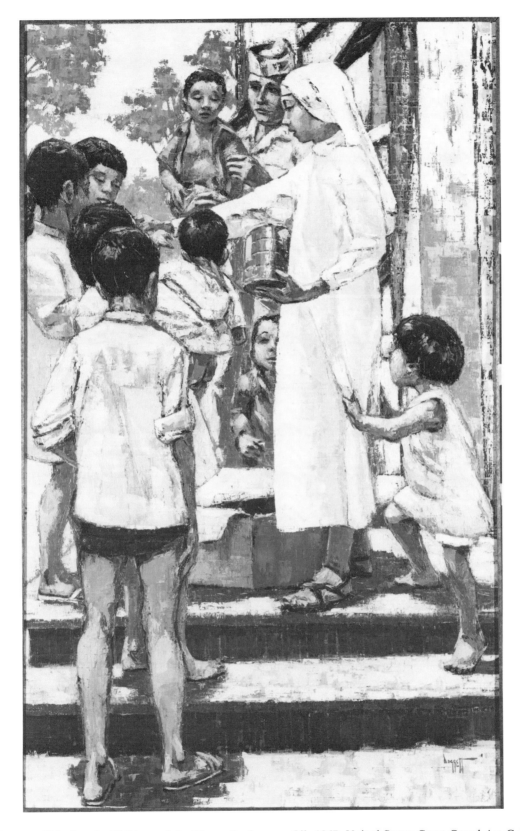

Noel Daggett. *Gifts for the Children of An Phong Orphanage*. Oil, 1967. United States Coast Guard Art Collection.

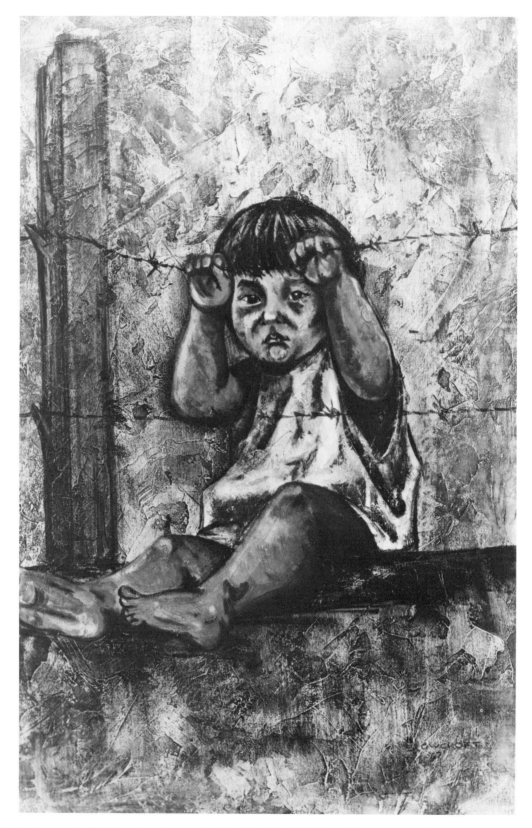

Kenneth J. Scowcroft. *Victim of the Times*. Acrylic, 17″ × 11″, 1967. United States Army Center of Military History.

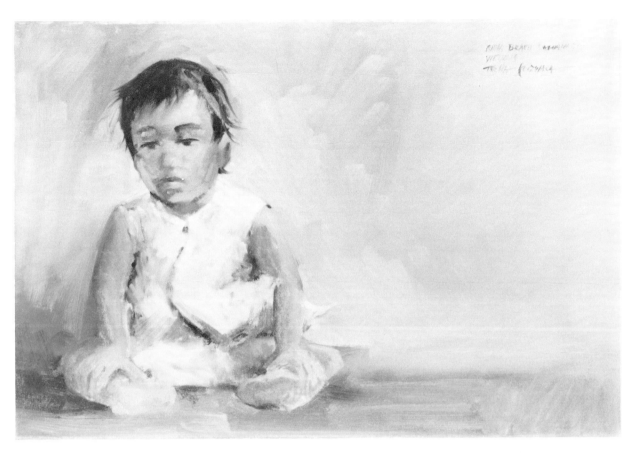

Trella Koczwara. *China Beach Orphanage*. Oil, 25″ × 37″, 1970. United States Navy Combat Art Collection.

Apollo Dorian. *Vietnamese Girls with Gifts from Coast Guardsman*. Oil, 1969. United States Coast Guard Art Collection.

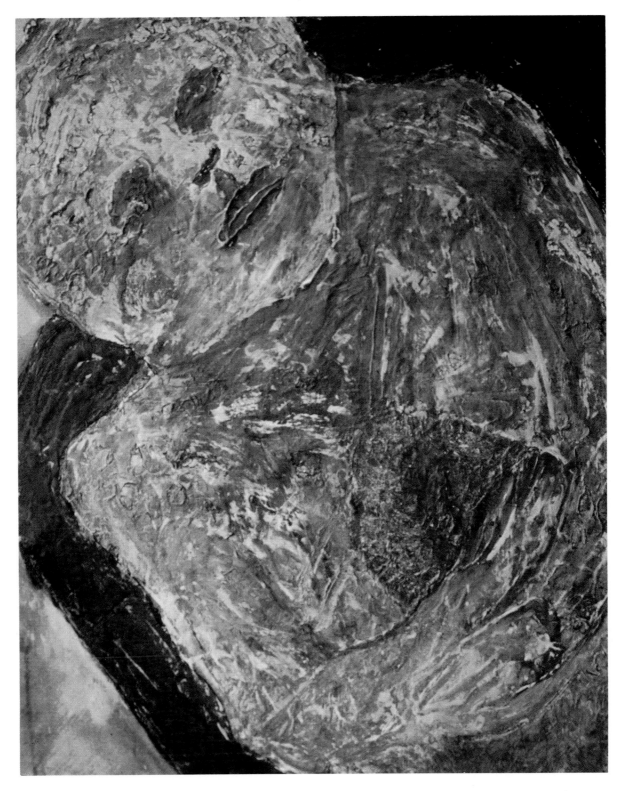

Jack McWhorter. *Man with a Stomach Wound*. Mixed media, 48″ × 48″, 1973. Courtesy of the Artist.

Following page: Tom O'Hara. *Marine Compound*. Oil, 20″ × 24″, 1958. United States Marine Corps Art Collection.

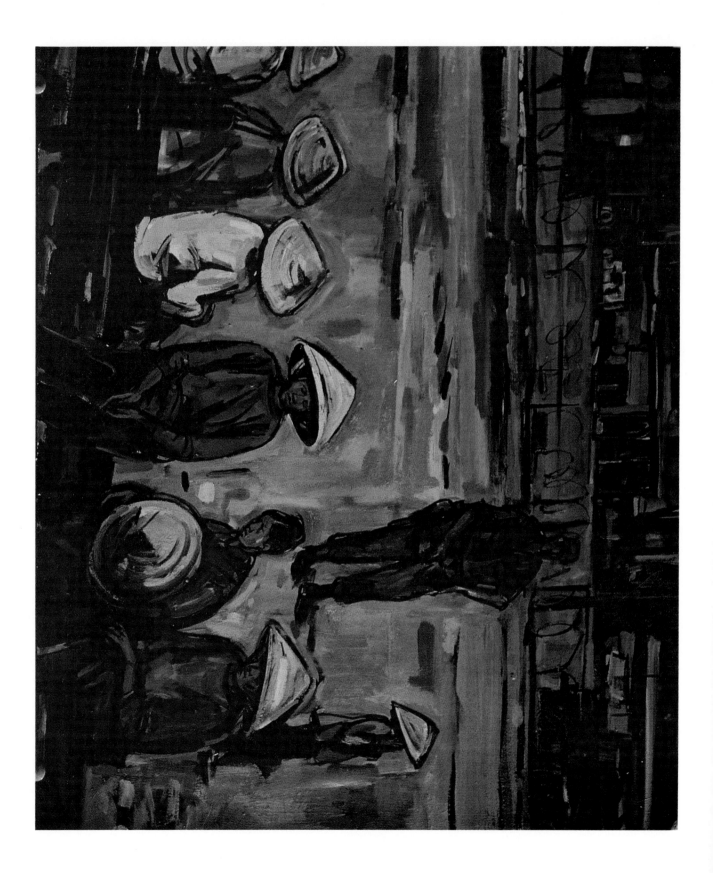

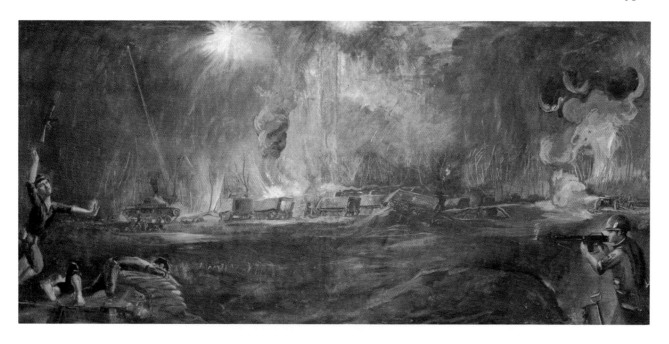

Jim Nelson. *The Battle of Soui Cut*. Oil and Watercolor, 8′ × 12′, 1967. Courtesy of the artist.

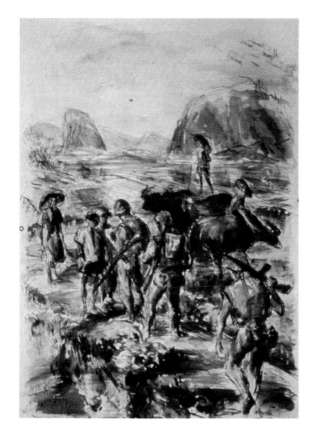

John Groth. *Marble Mountain Patrol Run.*
Ink and watercolor, 1968.
United States Marine Corps Art Collection.

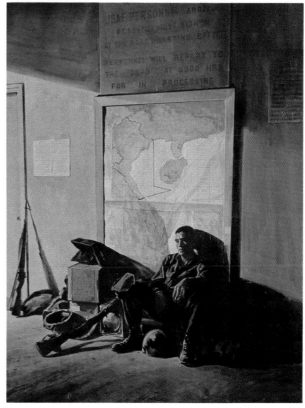

Attilio Sinagra. *Patiently Waiting—Da Nang*. Acrylic,
30″ × 24″, 1967. United States Air Force Art Collection.

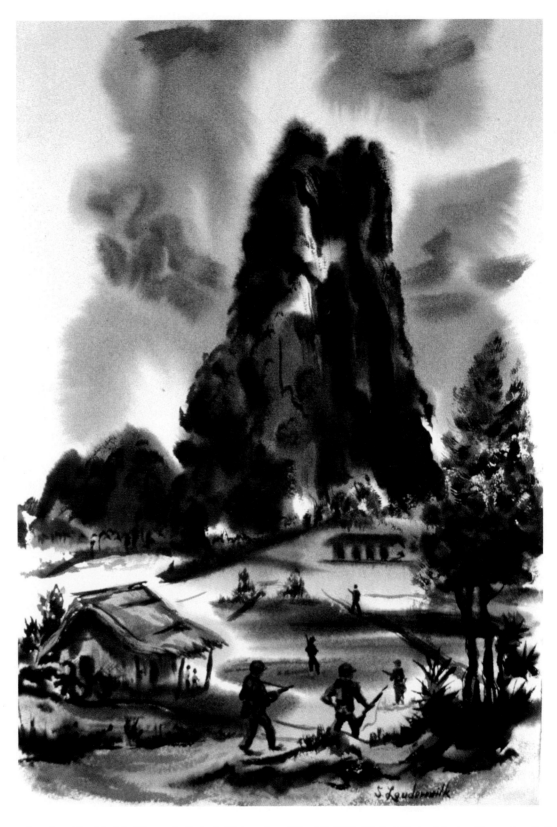

Sherman Loudermilk. *Marble Mountain Patrol*. Watercolor, 10″ × 14″, 1966. United States Marine Corps Art Collection.

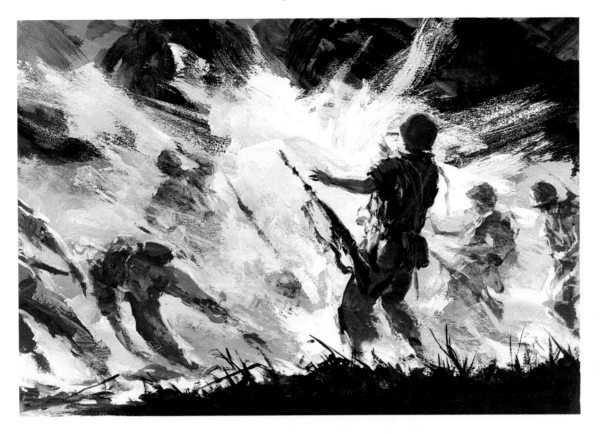

John Steel. *Mine on Patrol*. Acrylic, 7″ × 10″, 1966. United States Navy Combat Art Collection.

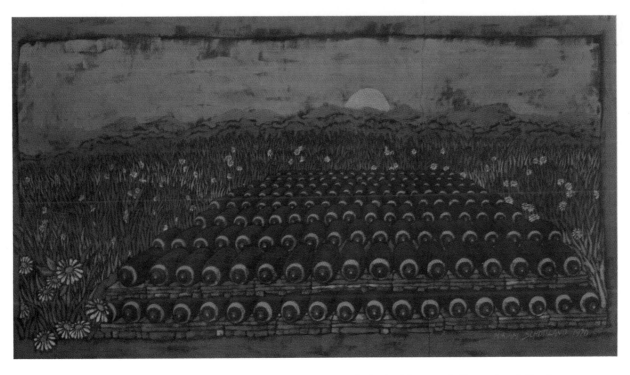

Miriam Schottland. *War and Peace*. Acrylic, 20″ × 36″, 1970. United States Air Force Art Collection.

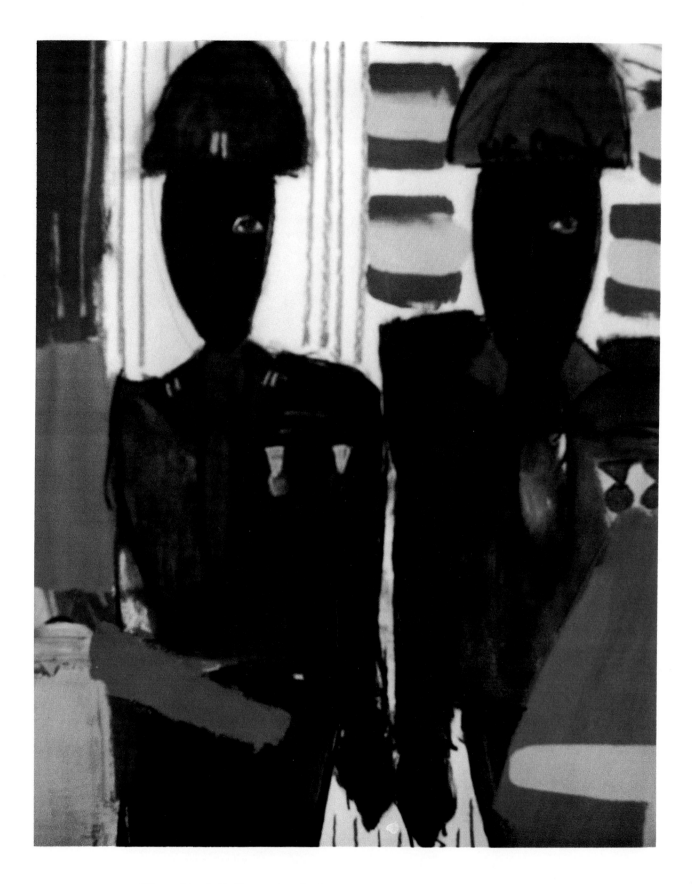

Ulysses Marshall. *Heroes*. Acrylic, 26″×18″, 1981. Courtesy of the artist.

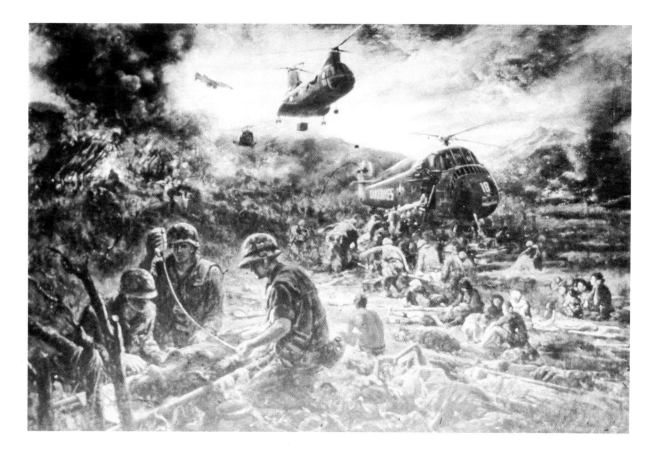

Robert Benney. *Vietnam Episode*. Oil, 30″ × 44″, 1969. United States Marine Corps Art Collection.

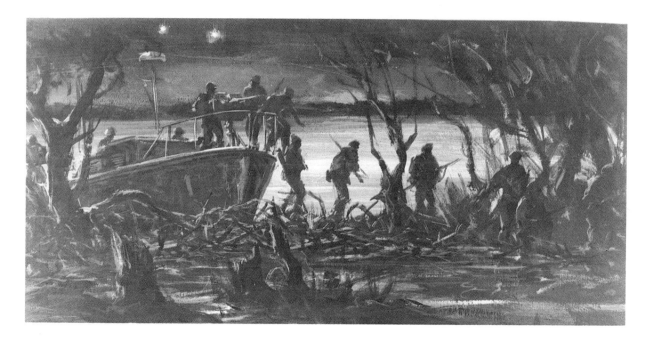

John Steel. *Seal Team Drop Off*. Acrylic, 6″ × 13″, 1966. United States Navy Combat Art Collection.

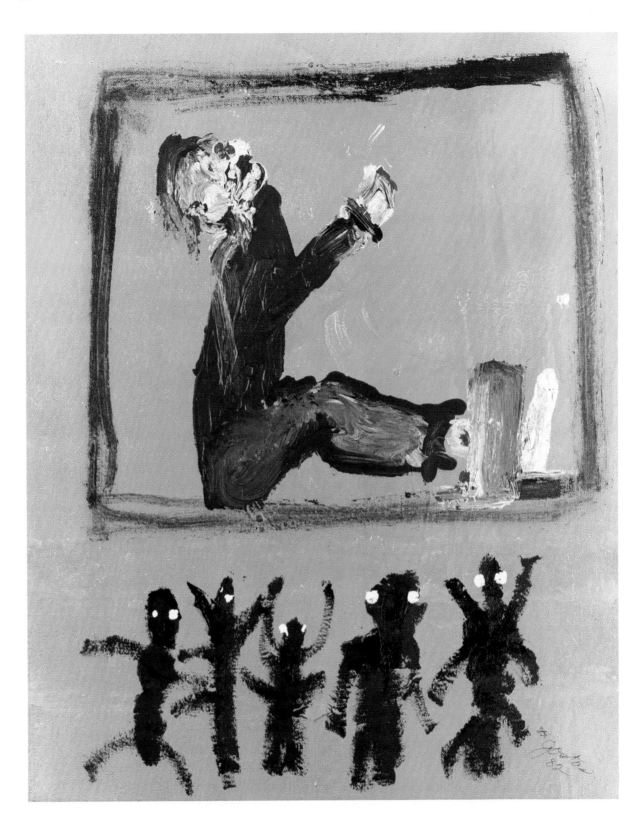

Theodore Gostas. *Solitary and Insects*. Acrylic, 20″×16″, 1982. United States Air Force Art Collection.

POWs

"Can you imagine someone putting you in a closet and closing the door and saying, 'See you in six months'?" Colonel Robinson Risner asked reporters at Andrews Air Force Base in 1973 following his release as a prisoner of war.

Theodore Gostas, another former POW held in solitary confinement for four and a half years, said, "I try to control my pain and express the experience through art."

At the beginning of 1973, just days after the cease-fire agreement between North Vietnam and the United States was initialed in Paris by Henry Kissinger and Le Duc Tho, 1,925 American POWs were slated for return to the United States. Some prisoners had spent more than eight years in confinement. A controversy exists to this day as to whether all captured Americans were indeed returned. As a result, the POW story is incomplete.

Gostas was an intelligence officer with the air force near Hue on February 1, 1968, when he was captured by the North Vietnamese. Because of his intelligence background, he was treated as a spy and spent most of his incarceration in solitary confinement. Upon his release, Gostas reportedly had eighteen abscessed teeth, an estimated 10,000 intestinal hookworms and a case of malaria. To bring himself back to reality, Gostas turned to art. Here, he tells his story:

There is no mystery to my art though some may find it mysterious. I am a war artist and if there is mystery in war it is only perceived as such by those who have not lived with war. In the pain of war, some objects and images may change form but they are never out of focus. My art is what it is because my pain has been too intense for any other form of expression, including screaming.

I tried poetry but soon realized that it was born of the excitement of freedom and was, therefore, not the best vehicle for expressing my appreciation of life, living, and basic existence. I decided that poetry was not nearly as important as the expression of my pain manifested in my painting and drawing. After all, I did my bit with fear and survived. Pain, however, was and sometimes still is the only adversary I buckle under to, and I pay pain tribute through my art.

I try to control my pain and express the experience through art. I try to avoid bedlam, the place where souls cannot communicate their anguish because they lack control. Control is the secret to communication and artistic expression. I force the viewer's eye to look at my art and thus, me. The viewer may rail at me, call me names, or even walk away in disgust. But he is changed because I have controlled my scream enough to let him hear it and see it.

Often, I hurry when I paint because my feelings of pain shift from one image to another instantly and I feel compelled to rush after them all—to express as many as possible. Usually, I find myself settling into a rhythm of brush strokes which slowly erodes away the anguish and loneliness precipitated by the pain. As a painting or drawing nears completion, I have a fear that I may only have screamed and not really communicated my feelings and experiences. When I know I have communicated, I am content and fulfilled as an artist.

I feel I have used symbolism and expressionistic imagery to describe my feelings

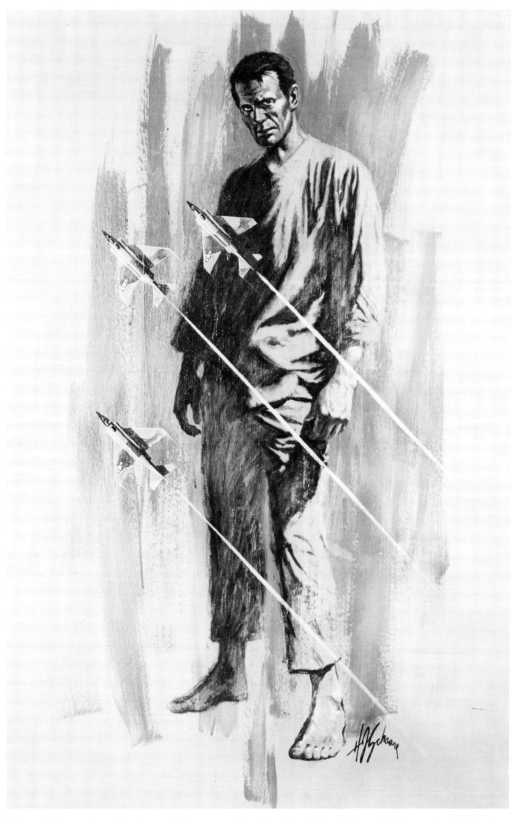

Harry Schaare. *Lest We Forget*. Tempera, 60″ × 48″, 1971. United States Air Force Art Collection.

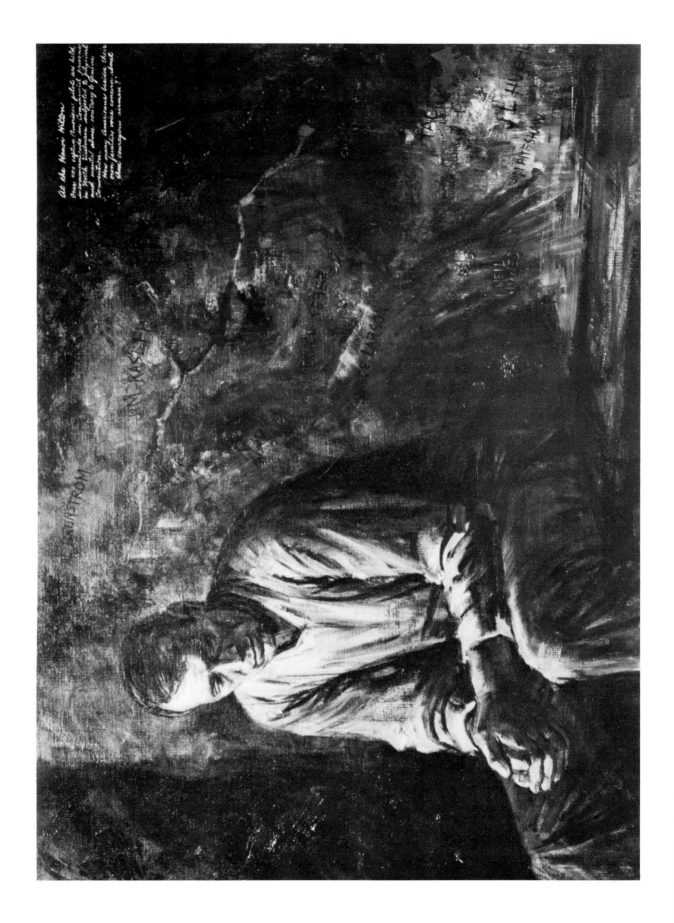

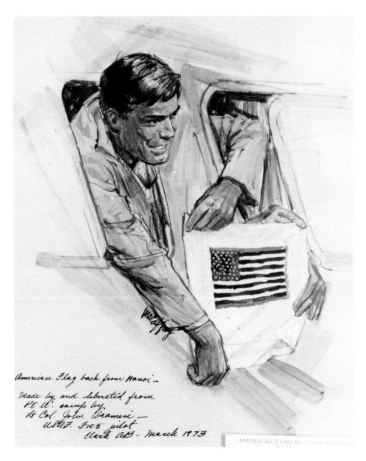

Maxine McCaffrey. *American Flag Back from Hanoi.* Acrylic, 12″ × 14″, 1973. United States Air Force Art Collection.

while incarcerated. Any fears about dealing with a discussion of prison and solitary confinement and warfare have been outweighed by my desire to have people know about these things and feel the futility of war.

I would like to hold a mirror up to war and hope that once it looks at itself, like Medusa, it will begin to die. I would not hope to be the instrument of war's death; such vanity is folly. War is too complicated and deadly to play like chess. I just want to keep on pushing war around, making it feel uneasy and afraid to sit down.

If you knew Gostas, he would send you a Christmas card during the holidays. One such card shows his sketch of a withered man holding a twig of a tree. Inside the card

you'd read, "Count Your Blessings." Most of Gostas's works are kept in his private collection, but in 1981 and 1982, the air force received four of his paintings for permanent collection in the art program.

Maxine McCaffrey was another air force artist who used the canvas to record the POW plight. From her travels throughout Southeast Asia, she often concentrated on painting the one subject that is every war pilot's fear—getting shot down and taken prisoner.

In describing her painting *At the Hanoi Hilton*, McCaffrey wrote:

The pilots flying over North Vietnam are quite bitter about the lack of concern by the American people for the 550 (their count) of

Opposite: Maxine McCaffrey. *At the Hanoi Hilton.* Acrylic, 50″ × 35″, 1967. United States Air Force Art Collection.

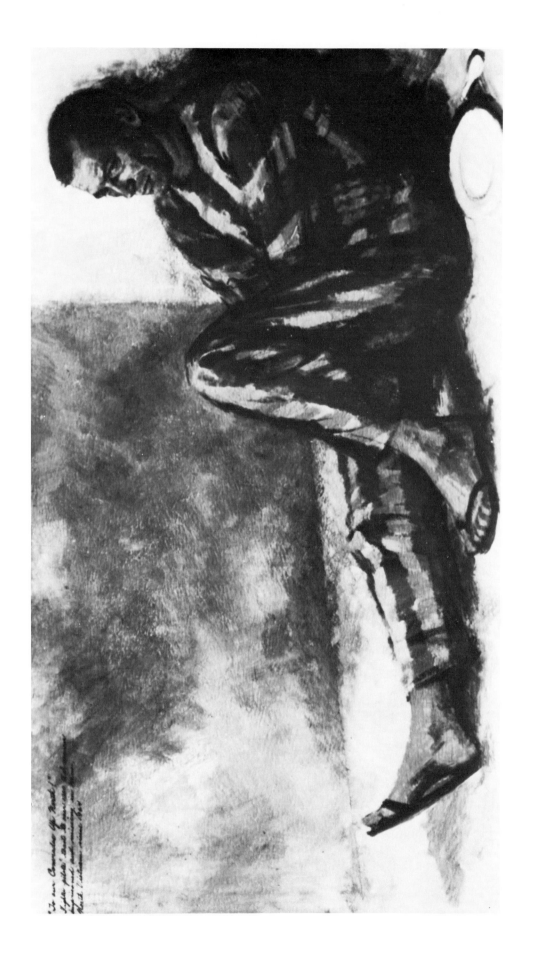

their comrades captured and held in God knows what conditions by the Reds. They remember Korea all too well. They also state that air force publicity, to the contrary, [claimed that] any pilot held in captivity by the Communists will never fly again in a responsible position or be trusted with heavy duty. . . .

[The pilots] are in constant touch with the captured men's families and showed me letters of the captured pilots' wives telling how hard they tried before getting the least little recognition from military authorities for their plight. As one pilot states, "Those 500 of our finest, most highly skilled pilots, are an embarassment to our government and therefore, our people choose to ignore them and probably hope they will die and go away. I sure haven't seen any protest marches organized about the POWs abuse!" So the pilots made me promise that I would paint one painting and dedicate it "to our comrades up North" as they say it.

McCaffrey noted in another of her paintings that the pilots had a unique sense of humor about their situation. "As one said about his paunch," she wrote, "'It's Hanoi Hilton reserve; I hate rice.' Not kidding or trying to be funny, he just knew someday he would be shot down and captured or worse. He faced [that knowledge] every day when he flew."

Opposite: Maxine McCaffrey. *To Our Comrades Up North*. Acrylic, 36″ × 40″, 1969. United States Air Force Art Collection.

Theodore Gostas. *Butt Stroke*. Acrylic, 20″ × 16″, 1982. United States Air Force Art Collection.

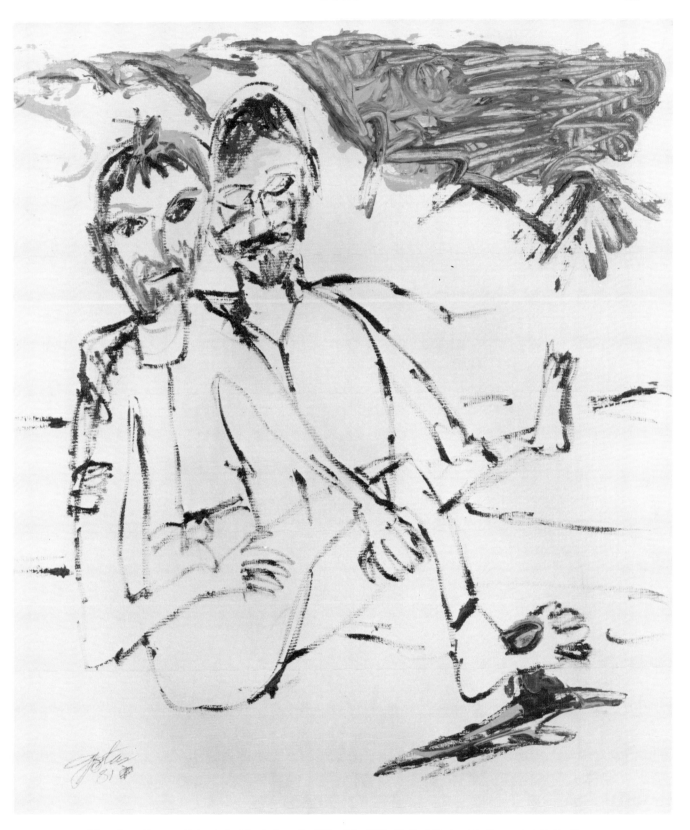

Theodore Gostas. *Friends in Need*. Acrylic, 20″ × 16″, 1981. United States Air Force Art Collection.

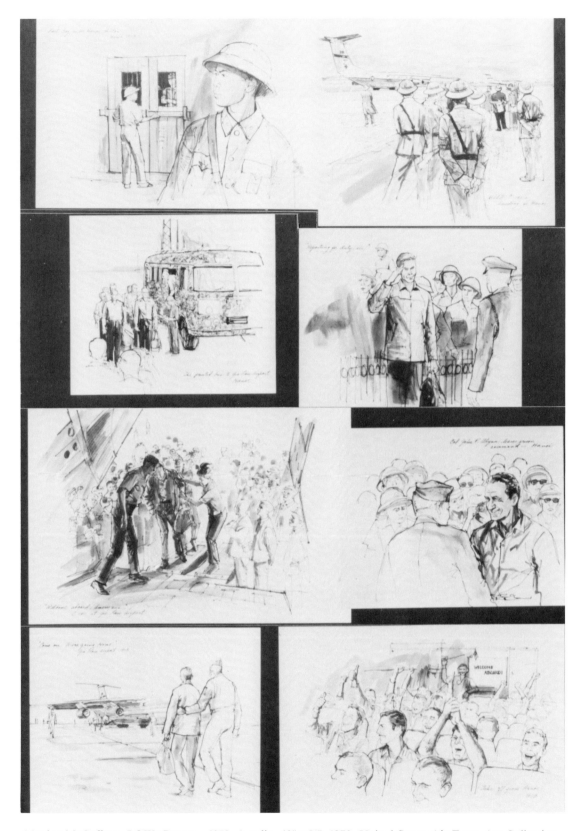

Maxine McCaffrey. *POWs Return—1973*. Acrylic, 40″ × 51″, 1973. United States Air Force Art Collection.

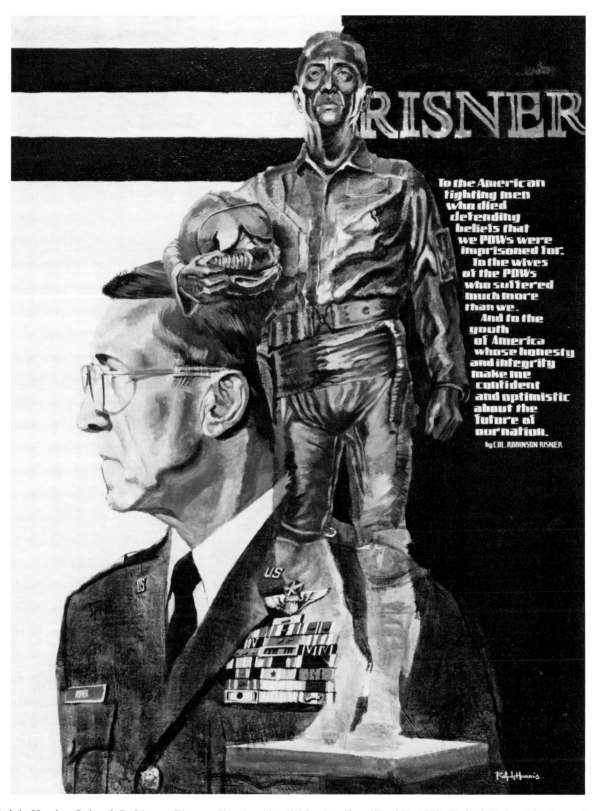

To the American fighting men who died defending beliefs that we POWs were imprisoned for. To the wives of the POWs who suffered much more than we. And to the youth of America whose honesty and integrity make me confident and optimistic about the future of our nation.

by COL. ROBINSON RISNER

Ralph Harris. *Colonel Robinson Risner—Keeping the Faith*. Acrylic, 49″ × 35″, 1979. United States Air Force Art Collection.

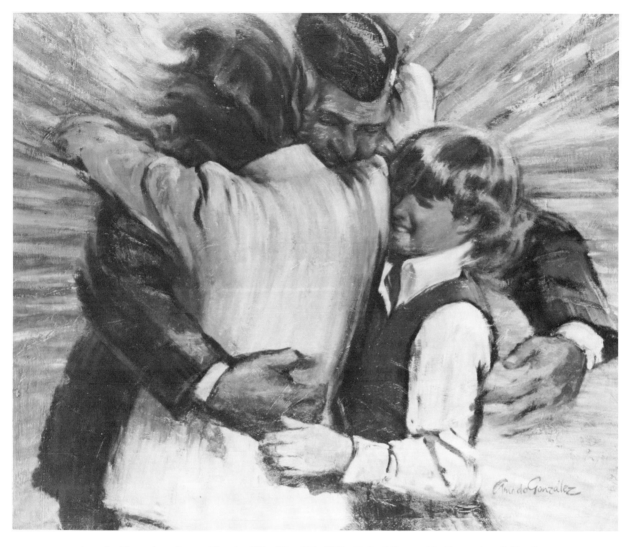

Amado Gonzalez. *Joy at Travis*. Oil, 49″×43″, 1973. United States Air Force Art Collection.

Opposite: George Shehorn. *Reunion*. Acrylic, 37″×28″, 1973. United States Air Force Art Collection.

Humor

On a "hot" landing strip—one subject to mortar or small arms fire from nearby enemy positions—aircraft transport will not quite stop when delivering their load of supplies and mail. As a transport lands, it will continue to roll down the runway while crewmen open the rear ramp and toss out the payload. If personnel are to be dispatched or on-loaded, they have to jump. Marine artist John Dyer knows this situation all too well.

Waiting in a trench alongside a runway for transportation to another assignment spot, Dyer saw he would have a 500-yard dash on open ground before jumping into the relative safety of a CH-46 chopper.

When the helicopter actually arrived, he began his sprint and easily made it to the runway, timing it perfectly so that he cleared the rotor and fell in right behind the helicopter's trail. But instead of jumping in, Dyer saw the crewman waving him off, signaling they weren't to take on any passengers. Before he knew it, Dyer heard the engines revving and then saw the helicopter take off, leaving him in the middle of the runway out of breath.

Fortunately, he encountered no enemy fire as he trudged back to the trench. The incident was hardly funny at the time. But today, although Dyer tells the story with a few expletives, he tells it with a smile.

The postscript to many jokes and stories about Vietnam was "You had to be there." One might inquire if there would be anything immediately and everlastingly funny about the Vietnam War, anyway.

Bill Mauldin, well known for his World War II cartoons of "Willie and Joe," concentrated on the ironies of army life during that war. Mauldin was well aware of the soldier's plight: "Look at an infantryman's eyes and you can tell how much war he has seen," he once wrote. Likewise, Richard Heath, a corpsman stationed with the Third Marines and then with the Military Provincial Hospital Assistance Program in 1968–1969, also found that cartooning provided him with comic relief in an otherwise tragic circumstance. He recalls:

I drew cartoons because I really could not take the navy seriously, or the military either, regardless how intimidating they were. I was a cartoonist; I enjoyed drawing cartoons and I had the knack of caricaturing situations that I was in. However, I never drew a single cartoon depicting South Vietnamese people because I could not make light of them in any way. They suffered then, they suffer now.

I was at Khe Sahn when the geniuses at MACV had us set up like clay pigeons. We were all stuck there, and laughing at the situation was the most productive way to spend the time around tending the wounded, dead and dying.

Now as the years separate me further away from the two years in Vietnam, I find it more comfortable never to discuss the Vietnam War with anyone. I went, I accomplished some things, I'm proud of what I did.

Heath tried selling his cartoon of a stethoscoped corpsman listening for tunneling Vietnamese to *Stars and Stripes* newspaper and then to *All Hands* magazine in 1968; both publications returned the cartoon with a rejection slip. *All Hands* claimed: "Since we are a publication of the Department of the Navy, we must follow certain criteria in selecting cartoons for publication.... Because of

My insurance company? SGLI, of course. Why?*

D.J. Lewis. Pen and ink, 1969. *Uptight* magazine.

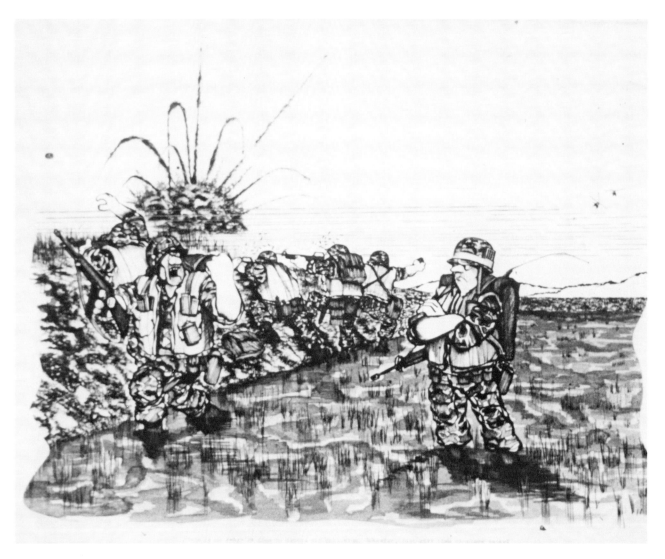

Teri Redknapp. *"This is no #@%¢*/#* time to debate air polution, Schaefer, just give them choppers smoke!"* Pen and ink, 16″ × 21″, 1969. United States Marine Corps Art Collection.

Teri Redknapp. Pen and ink, 16″ × 21″, 1969. United States Marine Corps Art Collection.

Teri Redknapp. *"Agreed Lieutenant, a bigger insult to the Corps dress regulations I've never seen . . . but I ain't about to tell them!"* Pen and ink, 16″ × 21″, 1969. United States Marine Corps Art Collection.

Teri Redknapp. *"That's the last of the ammunition, gentlemen, do we all have our Chieu Hoi cards available?"* Pen and ink, 16″ × 21″, 1969. United States Marine Corps Art Collection.

Richard Heath. Pen and ink, 9″ × 6″, 1969. Courtesy of the artist.

Richard Heath. Pen and ink, 9″ × 6″, 1969. Courtesy of the artist.

policy and other requirements we cannot use the material...."

Many of the cartoons that did appear in military publications, however, were staff-drawn by military personnel with the job title of illustrator. The unsolicited cartoons received by the magazines, if accepted, were purchased for one-time publication rights only.

The Marine Corps art program was the only one of the military to directly sponsor a cartoonist during Vietnam: Teri Redknapp. Redknapp's subsequent contribution of eight cartoons made up the second official cartoon collection of a military historical art program; the first was the assortment of cartoons within the *Yank* newspaper collection of World War II donated to the army following that war.

In August of 1966, the National Cartoonist Society, under request from the Department of Defense, sent Jack Rosen, Jon Nielsen and Don Orehek—all from New York at the time—to South Vietnam to enter-tain troops by caricaturing. The trio prepared a comic "chalk talk" program in which drawings of GIs in the audience were sketched and then passed out to their subjects. In addition, the three cartoonists visited various United States military hospitals throughout South Vietnam and at Clark Air Force Base in the Philippines, caricaturing the wounded in an effort to raise spirits. More than 2,000 drawings, were reportedly made and distributed to their subjects. Nielsen later wrote and illustrated his impressions of the trip in his book *Artist in South Vietnam.*

Today, cartoons about the war are still being drawn, although they are usually meant to be more ironic than humorous. They can be found in such publications as *National Vietnam Veterans Review* and chapter newsletters of Vietnam Veterans of America.

As the last word on Vietnam humor, it would seem that what "Kilroy was here" was to World War II, the T-shirt slogan "Participant, Southeast Asian War Games, Second Place" was to the Vietnam War.

(?) Minet. Felt Pen, 1971. *Long Binh Post* newsletter.

UNSUNG HEROES: CASE NUMBER 1
Postal People

Carson R. Waterman. Pen and ink, 1967. *Esprit* magazine.

Shortness is when you can't fit all your goodies into a duffle bag.

Shortness is when can take a bath in your helmet.

Shortness is hesitating to start long conversations because you may not have time to finish the next sentence.

Shortness is straining to find a white space on your short-timer's calendar.

Shortness is telling a "two digit midget" that if you had that long to go you'd shoot yourself.

Shortness is digging in at any noise louder than a cricket's chirp.

Shortness is when nobody you talk to understands what "TT" or "beaucoup" means.

Glenn Thompson. Pen and ink. *First Team* magazine.

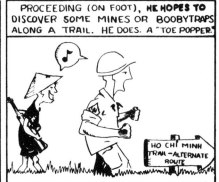

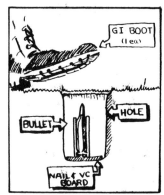

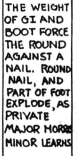

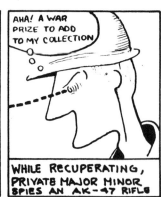

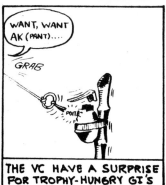

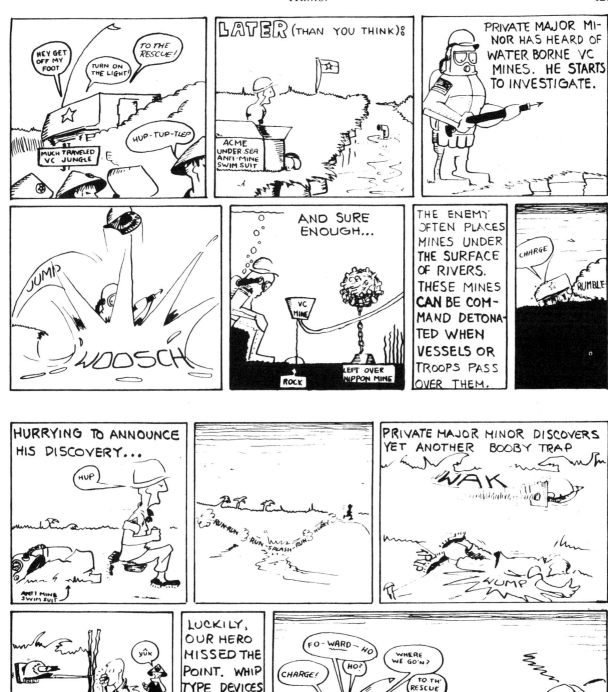

Artist unknown. Pen and ink, 1969. United States Army, Republic of Vietnam, Pamphlet 1-69.

Aftermath

The communist takeover of the government in Saigon on April 30, 1975, ended America's fighting role in Vietnam. But Vietnam was not necessarily over for many Americans. Veterans faced the frustration of trying to explain what it was like "over there." Some turned to art.

Ulysses Marshall, a combat veteran, had nothing but pain in his memories of the war. Using his talent as a poet and artist, he attempted to relieve the aftermath with paintings expressing healing and hope. He writes:

Vietnam is a painter's illusion
A Nightmare! From which I cannot awake.
A death unseen! A measure
of the suffering of man's despair.

My works of Vietnam are
influenced by the continued
sadness felt by my return home.

My work is what it means to fight
for freedom elsewhere. Where freedom,
dignity and respect aren't granted here!

My works of Vietnam are of being
Black in America.

Judged, sentenced and imprisoned
I had the courage
to honor
my family
with the flag after death

placed
over me
in a land that was never built
for me.

Similar reflections on the war were working their way out in the art of Jack McWhorter. He executed a number of paintings on his own while a college student after the war. The work left an impression on one of his teachers, who in turn convinced him to show it publicly. The public, however, was not prepared for the fear and horror that elucidated his experiences in combat, and many viewers were taken aback. He talks of how the war is being worked out in his art:

My art represents an emotional response to my experience in Vietnam during 1970. During the time I painted I was going through the process of self-actualization. I was confronting images in my experiences that were personally and deeply felt. Painting liberated me because I have a real need to paint and an intense desire to say something about what I went through. My attitude is also reinforced by the neo-expressionist painting that is dominating the art scene today, especially the German variety. Those painters are taking on the guilt and emotional baggage of the German past and exorcising it through their art. I can relate to that; I wanted to contain the essence of my Vietnam experiences in a physical way.

By using images and mythologies from distant times and places, people might understand that art is inseparable from life. In metaphorical terms, my painting Man With a Stomach Wound *functions as the first encounter with a wounded person; carrying a dying ARVN soldier up a hill to an LZ for medevac. The painting also functions as a haunting accident; directing fire of a 106 recoilless gun and seeing two rounds ricochet off wet elephant grass, veering three*

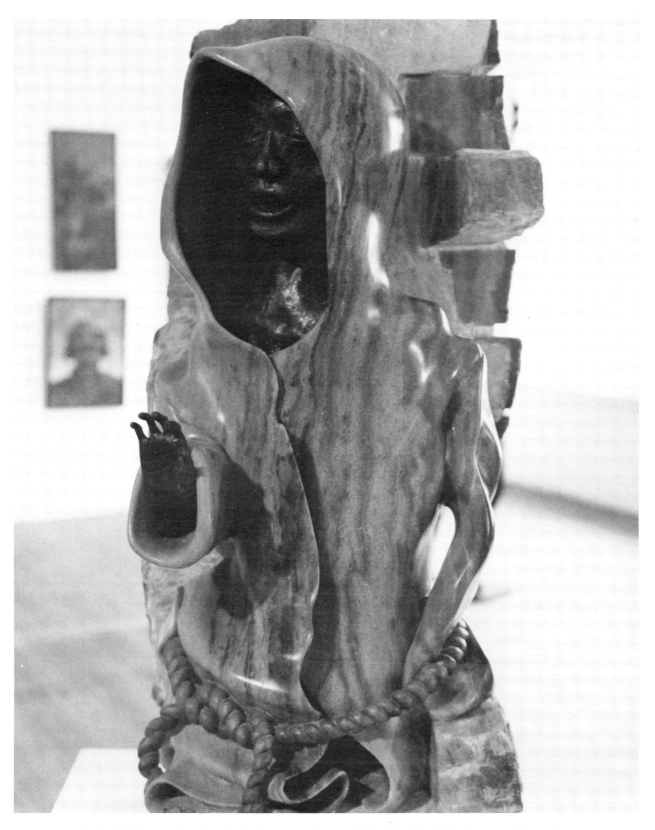

John McManus. *Abandoned*. Alabaster and bronze, 33″×15″×15″, 1979. Courtesy of the artist.

Mike Page. *Pietà*. Walnut, 28″ × 15″ × 12″, 1973.
Courtesy of the artist.

kilometers off target and landing in a village. In realizing this work I was able to put my personal experiences into a context I could understand and accept as a personal conclusion. In this respect, my painting is a kind of therapy for me.

The medium for portraying experiences in Vietnam was not always limited to a canvas. Mike Page sculpted his *Pietà* out of a discarded tree of walnut that had been sitting in a lumber yard for over five years. Work on it took two years to complete. Influenced by Michelangelo, Page began the sculpture as a tribute to the guys he served with in Vietnam. However, Page said the more he worked on it the more it changed meaning.

The Madonna figure has a face that is more androgynous in appearance which, Page says, is a look common to exhausted young men in war. Yet, the figure also means to him the fathers and mothers of soldiers at war. The child came to mean to him all children of war, young or old—a symbol of lost innocence and senseless death.

John McManus's *Abandoned* was sculpted from Utah alabaster and bronze. It is approximately the same size as Page's *Pietà* at two and a half feet high. McManus made the piece as a way of dealing with the pain he felt for the children he saw in Vietnam and for the death of a very close child-friend upon his return. He says the work made many separate parts of himself come together.

McManus's road back from Vietnam was not easy. He describes the journey:

Since my return from Vietnam, I had continually suffered from flashbacks of my experiences and each night I would undergo a personality change. Although I looked as normal as the next person, at night I felt I was still a soldier in Vietnam, cut off from my unit. I believed everything and everyone around me was the enemy.

I felt like a failure and a coward who couldn't cut it. I believed most "men" dealt with this stuff, they didn't talk about it— right?

I was trapped within my mind, which continually picked on me. It locked me in a fear which even kept me from speaking. However, after constant prodding from the staff at the VA hospital I had checked into, I finally let go of my feelings one day and screamed a barrage of hate and anger. Some words were real and some fantasy, but all were painful.

After several months of group therapy, I was allowed to go to a nearby college to continue my search for sanity. I hoped to find some answers in the psychology courses I signed up for.

I answered an ad at school for a live-in

position to take care of a sick six-year old boy named Jonathan . . . I took the responsibility and moved in. Jonathan had lupus, a blood disease which kept him from going into direct sunlight. I cared for him three days a week.

Jonathan at first felt threatened by me and wouldn't cooperate, yet I couldn't help but notice he had an incredible will to live. I'd watch him walk and, invariably, fall. Yet he would get right back up and try again. There were times I would run back to the VA hospital screaming "Why doesn't he lie down and die? I would if I could." The hospital staff would push me back to Jonathan and tell me to learn to deal with and appreciate his struggle.

In time, Jonathan and I became friends. I always treated him like a person and not like a dying child. But soon after he was well enough to go to school on his own, I left his house and took up my old trade of cabinet-making. After many business attempts, I returned back to the same college and chose a basic stone sculpting course.

Then, following many relapses over the years, Jonathan suddenly died. Even though I knew when we first met that someday he would die, I was still unprepared. I wanted desparately to go back into my old familiar world of silence which was filled with hate and anger.

Several weeks later, still in pain and grief, I returned early to my room above a nursery school where I was living, but the children were still there. I was determined to keep my distance as I wasn't going to get close to anyone again, it was too painful.

Suddenly, I saw a little two-year-old trip and fall. Before I realized what had happened I was holding the child on my lap with four or five other children crowding around me; they all wanted hugs at the same time.

At that point, my walls came down. . . . Jonathan had given me the gift of unconditional love and now I was learning to share it with others.

McManus placed his sculpture *Abandoned* in an exhibition at the Santa Monica College library in 1982, but an official of the college requested he remove it because it was "too depressing." He has since been invited to show his work in the House of Representatives Cannon Building Rotunda in Washington. He also travels with exhibits of the Vietnam Veterans Art Group.

Peter Dunne had been back from the war over ten years. An ex-marine, he had a good job in an art department of a large company. One weekend, the war hit home, as he describes:

I was having trouble with my relationship with my family . . . generally close feelings were being challenged by a tragedy and a death and we were all fighting with each other and all crazy, etc.

So, after a particularly hot battle, I retreated to things that were less trouble and began to draw pictures to hurt people. I figured that Vietnam scenes would do it.

Dunne said that as he progressed with his drawings, he realized that he was really venting his anger about Vietnam. He drew very quickly and found himself sketching scenes of brutal memories of the war. One sketch was of an old villager trying to receive compensation from the army for the death of a young child. The man wanted fifty dollars. Another memory was of a field morgue. Dunne recalls:

When I went to identify the bodies that day, the atmosphere was very surreal, more so than usual. The day was hot and dusty and in the basin where they had located the field morgue, the road into it made you feel like you were going someplace extra weird. That struck me a little, that the morgue was down in a valley.

One of the things I saw first was a guy washing bodies. I was amazed at how diligent he was at his job—sponging and soaking the

body, then grabbing an arm and leg and "umph-ing" it over onto the stomach. This poor corpsman had been sponging off the mud, spiffing up the body for mom.

Maybe because I was a "kid" at the time, I felt like there should have been more of a ceremony. But the corpsman could have been washing a car. Also shocking to me were the nearby body bags with more dead men to be cleaned, next to a pile of dirty uniforms.

Dunne said that he began to calm down after getting the facts of his particular memories into the sketches, but he has not returned to them for completion. Now he feels that the drawings are a depiction of something less brutal than what he really saw; the actual scenes eventually worked themselves into something almost pastoral. Nonetheless, Dunne made his point through his art, if only to himself.

Epilogue

The history and museum branches of the military services still maintain contact with many of the artists they once employed. In October 1983, the Marine Corps sponsored a military art symposium and invited each of their former Vietnam artists to attend. The air force still utilizes the talents of many of their Vietnam artists, such as Keith Ferris, to cover space launches and other important milestones of their mission.

Only a handful of the soldiers and marines who participated in a combat art program remained in the service following the war. Many of the civilian artists now have successful art careers or well-established private businesses. Some, such as Mitchell Jamieson, Tom O'Hara, Maxine McCaffrey and Raymond Henri, have since passed away.

The most fundamental outlet for post-Vietnam artists to show their work is the Vietnam Veterans Art Group, an apolitical organization that is dedicated to providing an artistic and historical view of the war. The group has already exhibited in many major cities across the United States. Most of the artists in the group said they executed their work during the war but could not favorably show it due to the political climate of the time. Their recent exhibits have been critically appraised.

The veteran/artist seeking to show his Vietnam-related work at galleries across the country continues his struggle for understanding. What his art and all other combat art proves, if anything, is that an opinion can be formed or influenced without words.

Index

JOSEPH F. ANZENBERGER, JR., served in the United States Marine Corps and received his degree from Pace University in New York. He presently works and lives near Washington, D.C.